A COLORING ADVENTURE IN MATH AND BEAUTY

PATTERNS

OF THE

UNIVERSE

Alex Bellos AND Edmund Harriss

THE EXPERIMENT

NEW YORK

ACKNOWLEDGMENTS

Thanks to the artists credited here for kindly letting us use their wonderful images, and thanks to Faye Keyse, Kelly Cheesley, Zoe Margolis, and Letty Thomas for giving us feedback on the designs. Karen Giangreco at The Experiment and Katy Follain and Rafi Romaya at Canongate have done a fantastic job, as have Rebecca Carter, Rebecca Folland, Emma Parry, and Kirsty Gordon at Janklow & Nesbit. Alex's wife Nat and Edmund's wife Åsa were both incredibly supportive, and we couldn't have done it without them.

The Experiment, LLC
220 East 23rd Street, Suite 301
New York, NY 10010-4674
www.theexperimentpublishing.com

The Experiment's books are available at special discounts when purchased in bulk for premiums and sales promotions as well as for fund-raising or educational use. For details, contact us at info@theexperimentpublishing.com.

Library of Congress Cataloging-in-Publication Data

Names: Bellos, Alex, 1969- author. | Harriss, Edmund, author.
Title: Patterns of the universe : a coloring adventure in math and beauty /
 Alex Bellos, Edmund Harriss.
Description: New York : The Experiment, [2015] | "Simultaneously published in
 Great Britain in 2015 as Snowflake, Seashell, Star by Canongate Books."
Identifiers: LCCN 2015036475 | ISBN 9781615193233 (print)
Subjects: LCSH: Pattern perception--Juvenile literature. | Symmetry--Juvenile
 literature. | Mathematics--Juvenile literature.
Classification: LCC BF294 .B45 2015 | DDC 510--dc23
LC record available at http://lccn.loc.gov/2015036475

ISBN 978-1-61519-323-3

Cover and text design by Sarah Schneider

Manufactured in the United States of America
Distributed by Workman Publishing Company, Inc.
Distributed simultaneously in Canada by Thomas Allen & Son Ltd.

First printing October 2015
10 9 8 7 6 5 4 3 2

INTRODUCTION

Mathematics is a world of eternal truths and abstract perfection. Exploring its transcendent beauty can be a spiritual experience.

This book is both a field guide for the mathematical adventurer and a therapeutic exercise book designed to bring insight and illumination through the meditative experience of coloring.

Not only are the images exquisitely pretty, but they unlock the secrets of an intellectual quest that has been underway for at least three thousand years. Mathematics is the search to understand the patterns of the universe in their purest form.

No mathematical knowledge is required or assumed. But even in your selection of which colors to use, you will be engaging and enhancing your mathematical intuition.

The book has two sections, *Coloring* and *Creating*: The first offers completed images for coloring in, while the second gives you simple rules to follow so that you can create your own images. If you are curious about the designs, you will find brief explanations. But you're also welcome to simply explore the images for yourself.

Escape to Numberland. Relax. Focus. And enjoy the view.

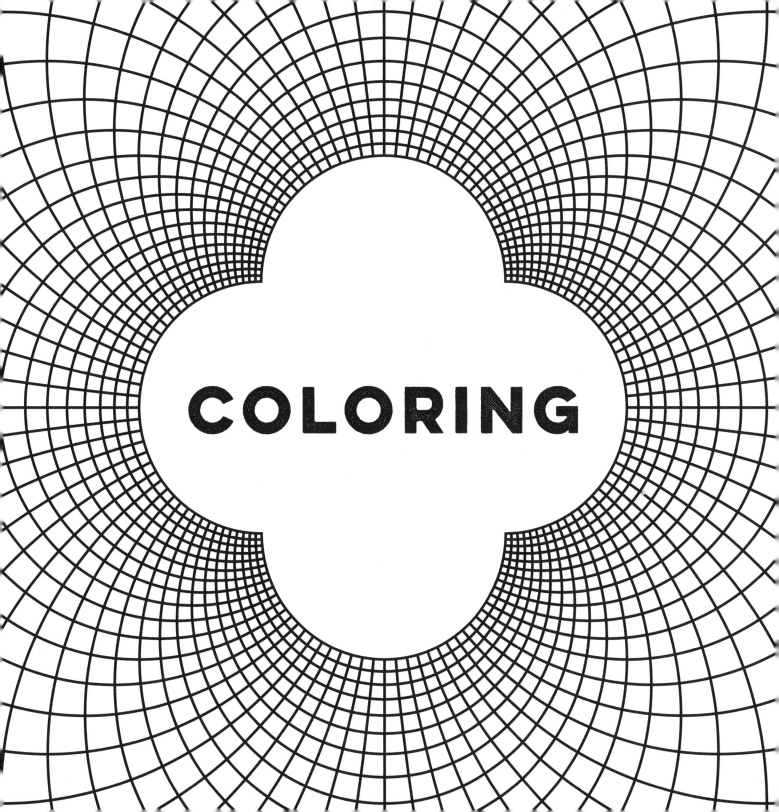

MANDALA

A geometric composition with Buddhist and Hindu symbolism

SRI YANTRA

The best-known and most geometrically complex Hindu mandala: nine interlocking triangles with a dot, or *bindu*, in the middle. The Sri Yantra has many metaphysical interpretations and is used for meditation and worship. Om.

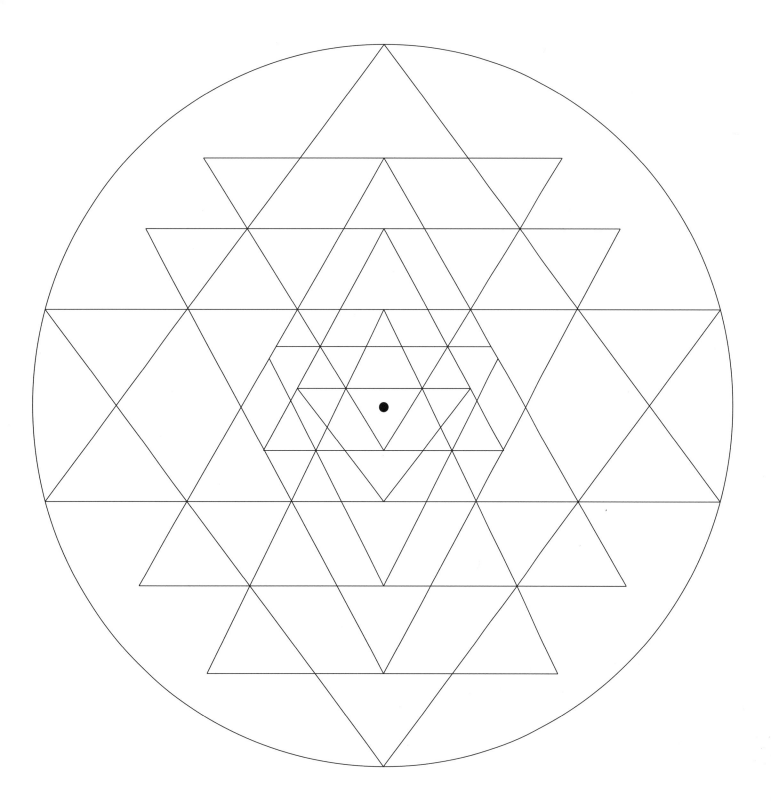

VORONOI DIAGRAMS

Dividing the plane into cells with straight sides

In 1908 Georgy Voronoi wrote a paper on the geometry of crystals in which he described patterns now known as *Voronoi diagrams*. Below are the first three steps for constructing them. Turn the page for the last . . .

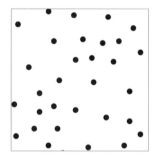

First, start with some dots.

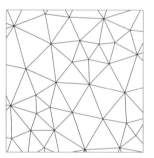

Next, join each dot to its immediate neighbors to get a network of triangles.

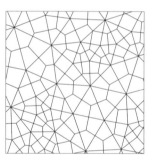

Then let each dot be in its own cell, such that the cell boundaries are all straight lines exactly halfway between dots, and perpendicular to the lines of the triangles.

BARNACLES

At the third step, the image has an organic, crustaceous feel.

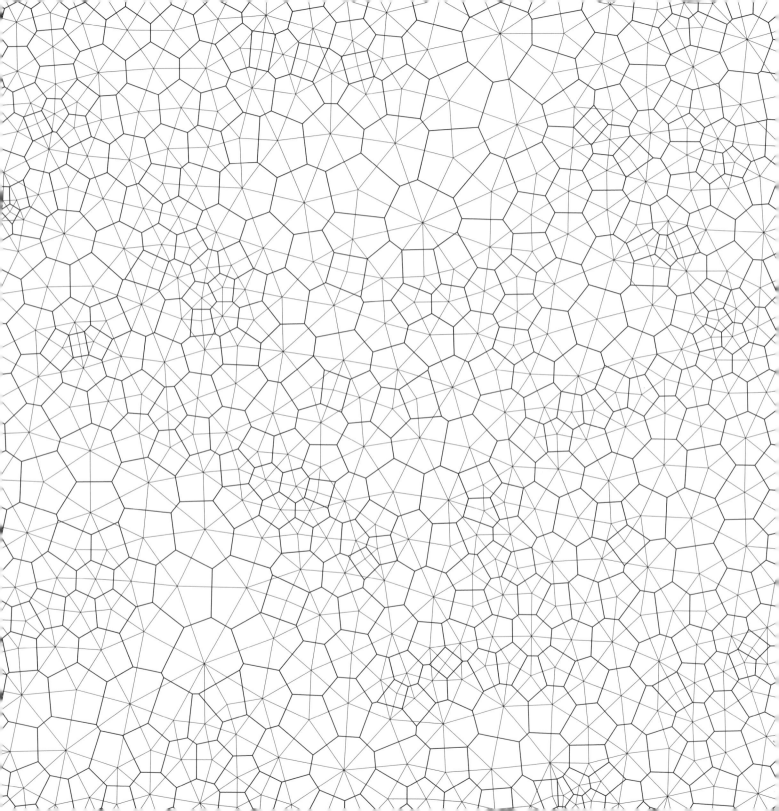

BUBBLES

The fourth step is to remove the triangles and dots, revealing a bubbly geometric soap froth—the finished Voronoi diagram.

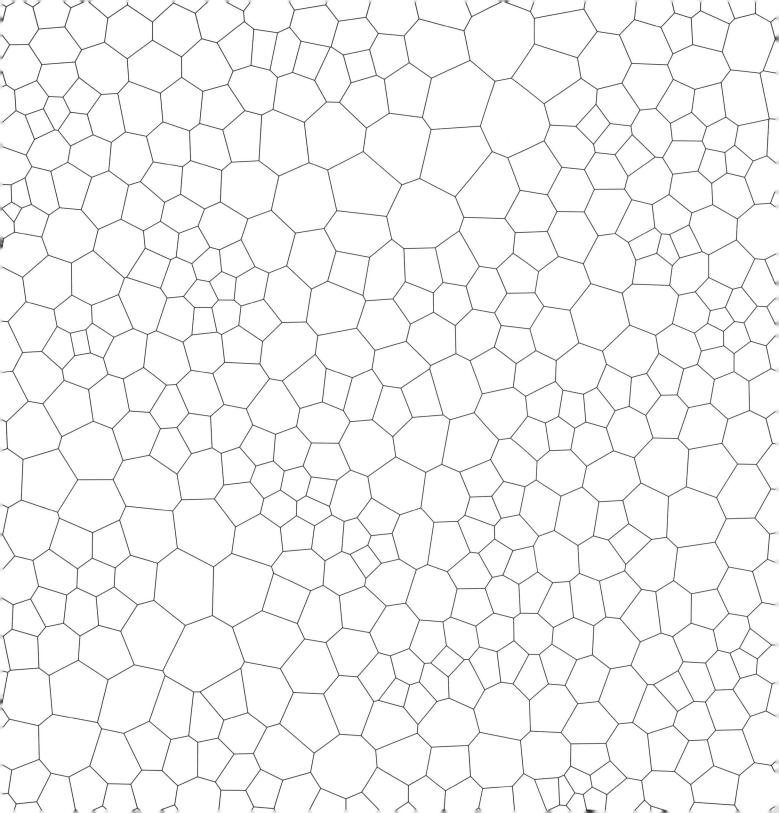

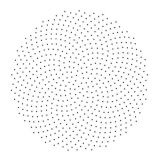

SUNFLOWER

Unlike the previous Voronoi diagram, seeded by a haphazard sprinkling of dots, this one emerges when the original dot pattern is the sunflower spiral above.

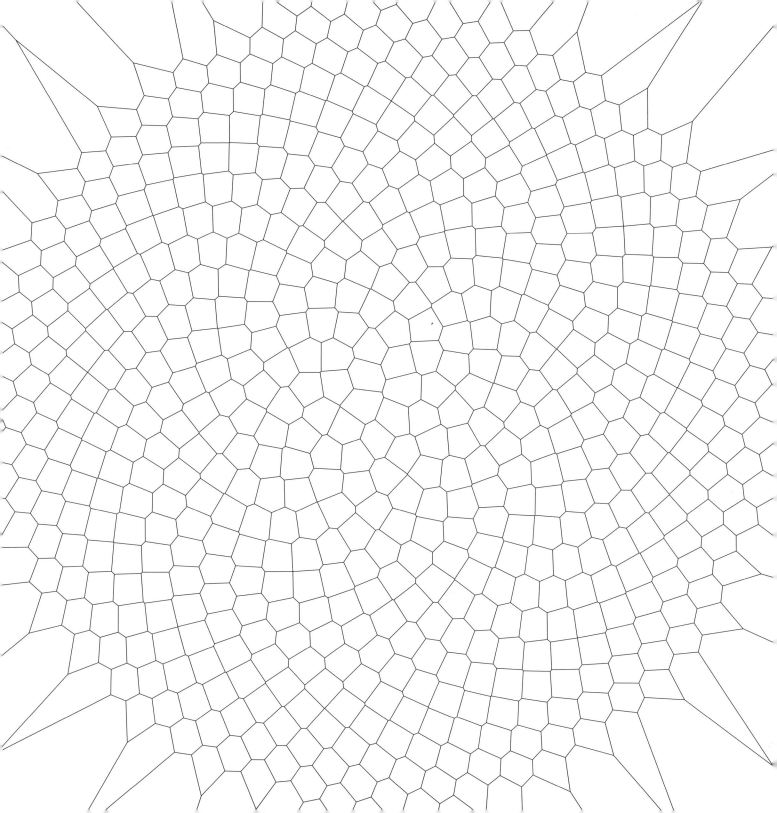

STAR

The eight-pointed star pattern above gives us this Voronoi diagram.

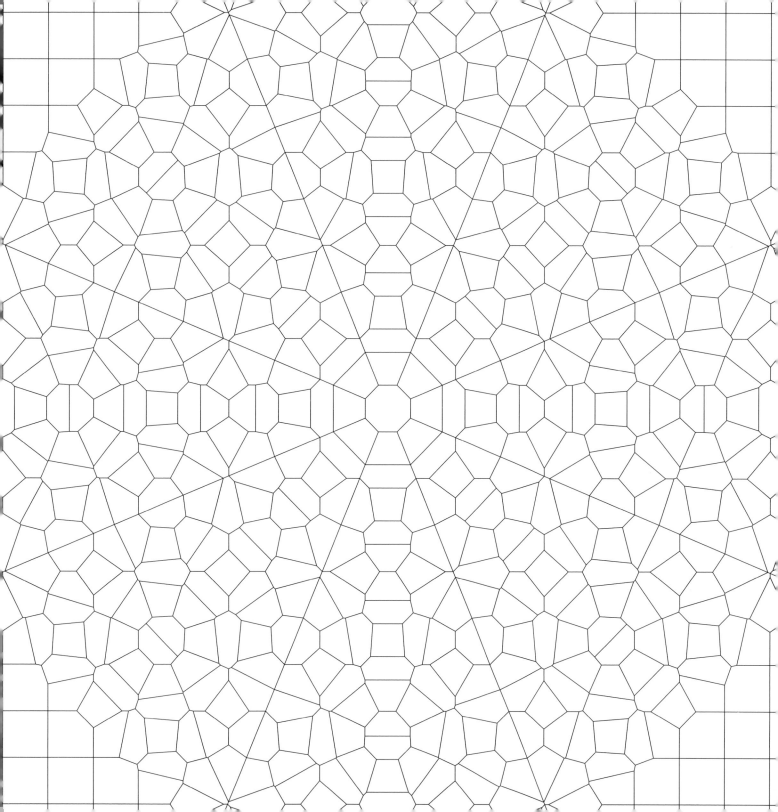

TRANSFORMATIONS

One pattern morphs into another

TWIRL THE WORLD

You start at the North Pole and head south, while also bearing east at a steady angle. Your path will spiral around the globe and at some point reach the South Pole. This image is a map of the Earth, where the two black dots are the poles and the lines are 20 spiral paths heading in a fixed direction southeast, together with 10 in a perpendicular direction southwest. The three-dimensional spirals are thus transformed onto the two-dimensional page. If you look at the image carefully you will see that the map retains the angles—as on the Earth, the lines cross only at right angles.

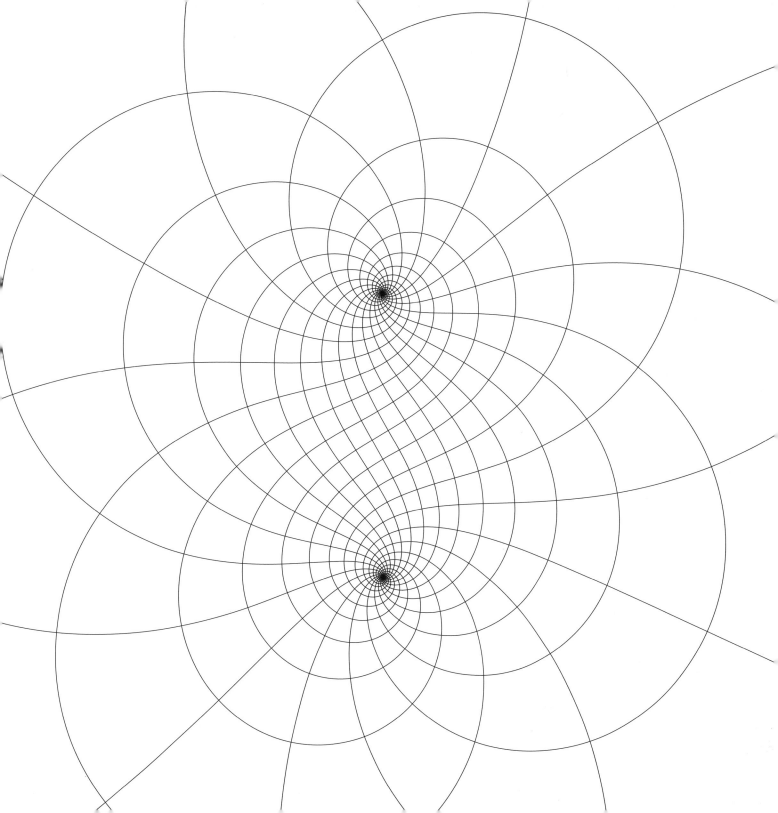

BENT BARS

The starting pattern can be thought of as prison bars: a grid of horizontal and vertical lines arranged evenly apart on a graph. Imagine bending the metal. Every vertical line is transformed into a circle that touches the central point and is cut in half by the horizontal axis, and each horizontal line is transformed into a circle that touches the central point and is cut in half by the vertical axis. For those of you familiar with complex numbers—which are too, er, complex to describe in such a short space—the mapping takes every point z in the complex plane to its inverse $1/z$.

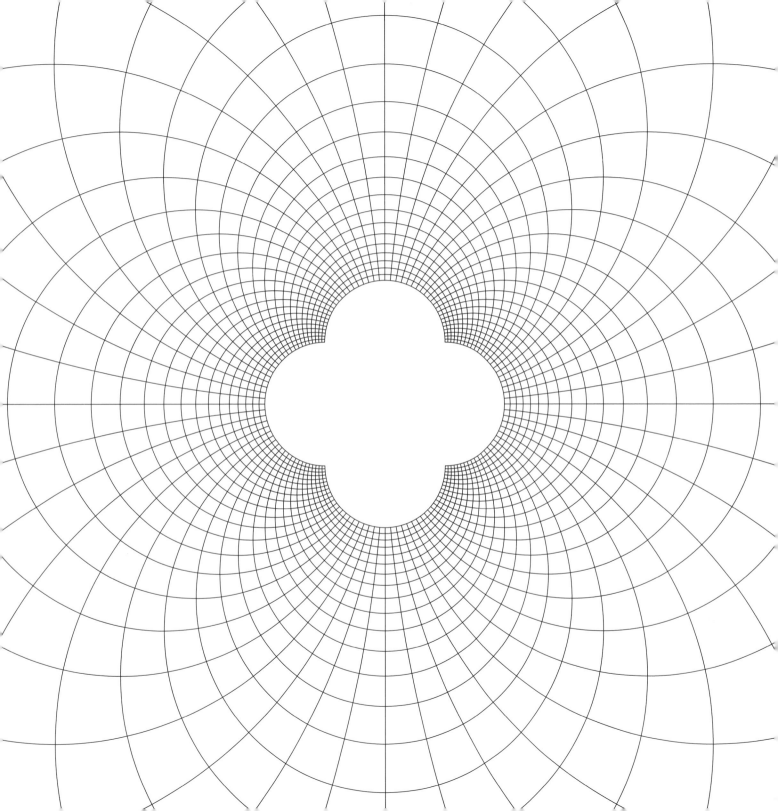

PETIT FOURIER 1

Imagine a Pacific archipelago consisting of eight tiny islands arranged in a circle. This image can be thought of as a map of the waves flowing around them. It was created by applying a *Fourier transform* on a circle of eight dots. The transform, discovered by Joseph Fourier in 1822, underlies our mathematical understanding of waves.

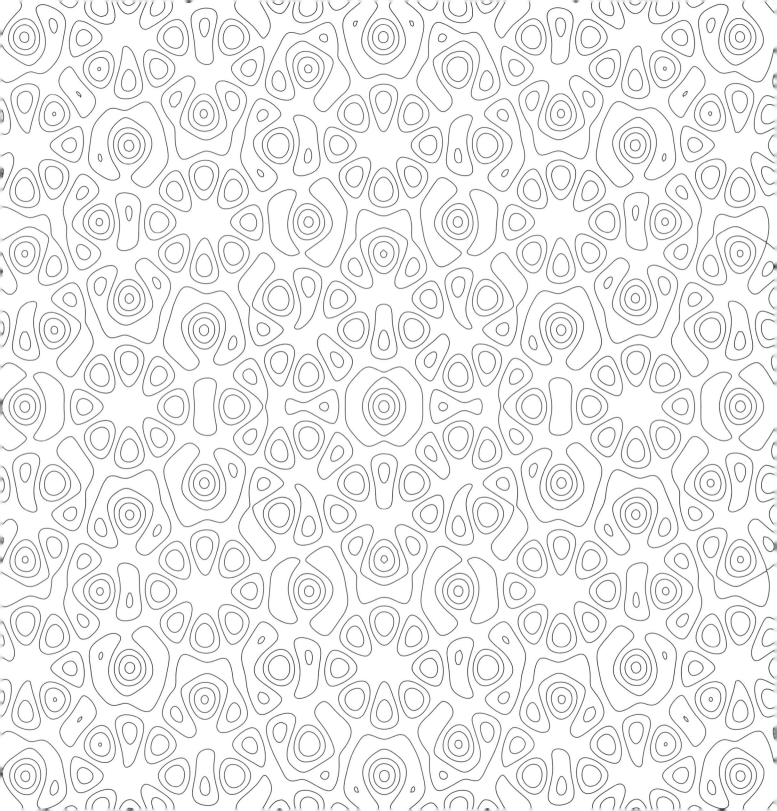

PETIT FOURIER 2

Another Fourier transform, this time starting with 14 "islands." The result is reminiscent of tribal art.

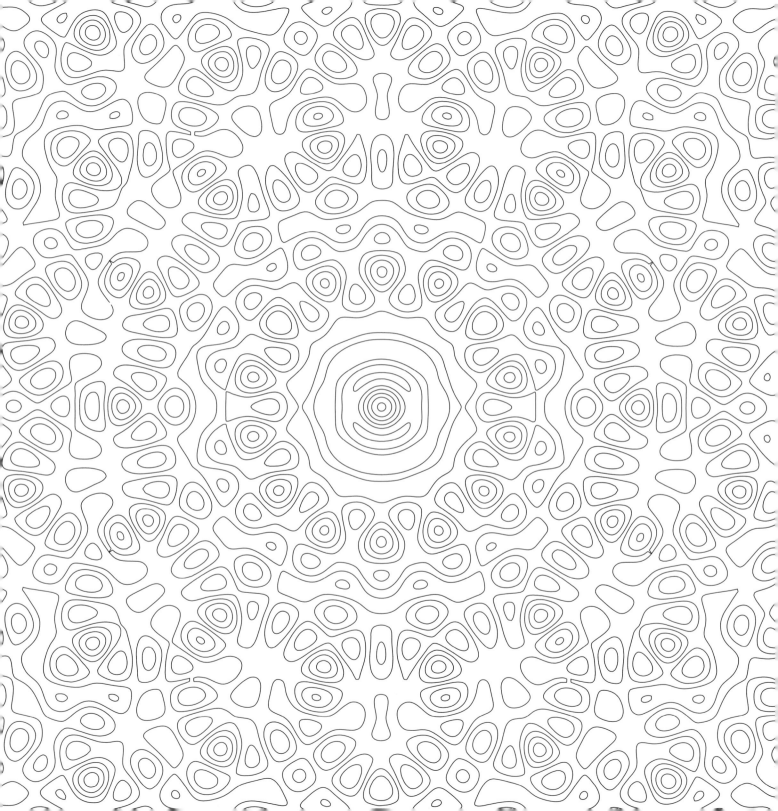

FLOWING WAVES

These calming swerves emerge from a notoriously uncalming area of math—calculus—which is where many students find that math suddenly gets hard. Calculus is the math of flux and change. Each line is a solution to the same equation with a different starting value. The interdependence of the rates of change of the variables produces naturally flowing waves.

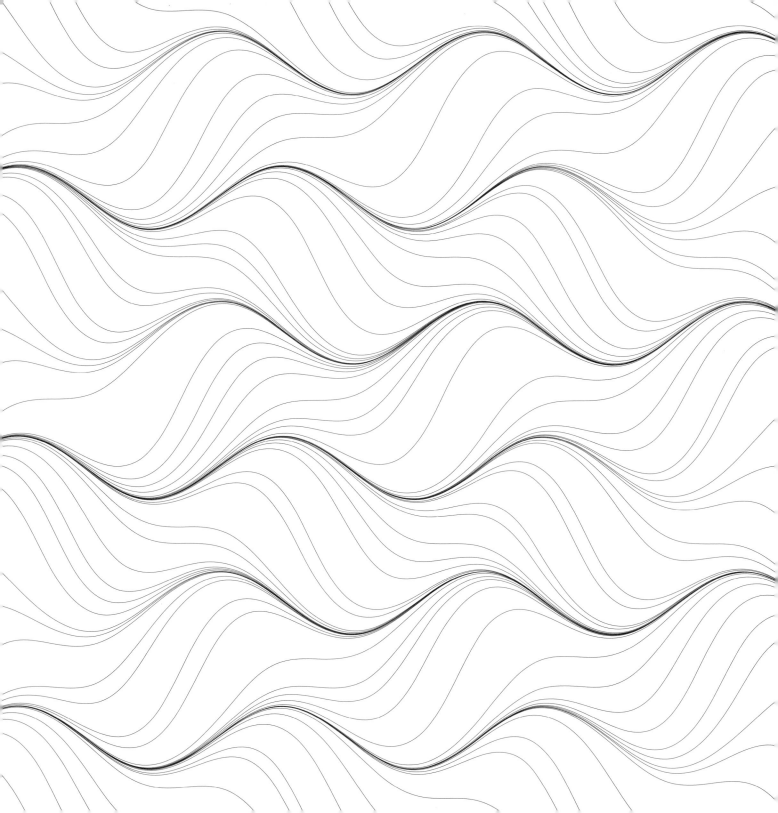

CASCADING WAVES

Another beautiful image born of calculus! Like the previous image, this one was generated using an equation from a class Edmund teaches.

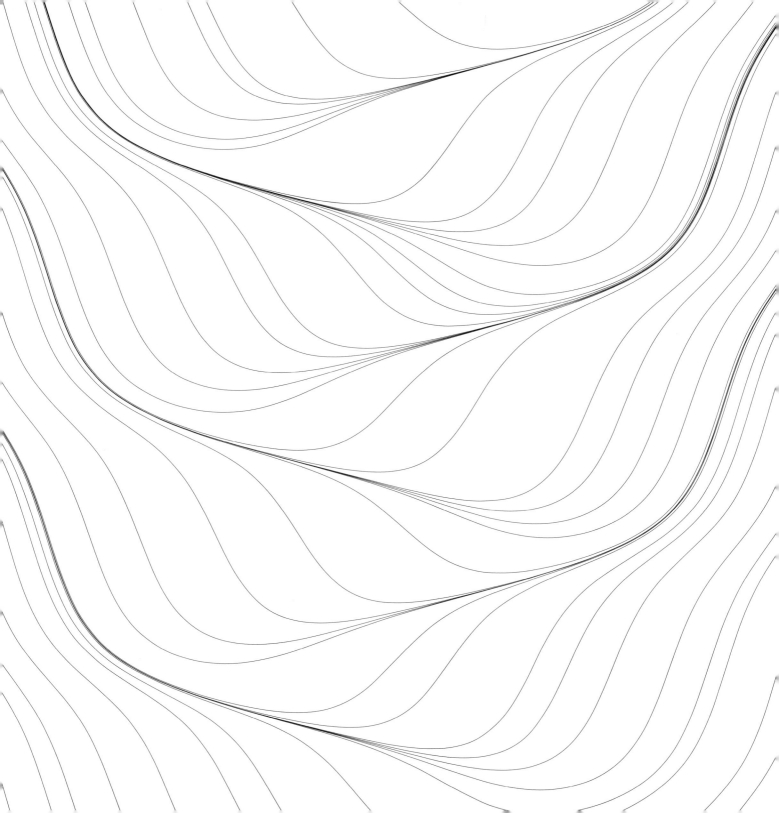

READ THE SINES

A tiled roof? No, it's the crests of a mathematical ocean. The curve above is a *sinusoid*, or sine wave, which is the simplest form of wave. At right, regiments of sine waves recede into the distance.

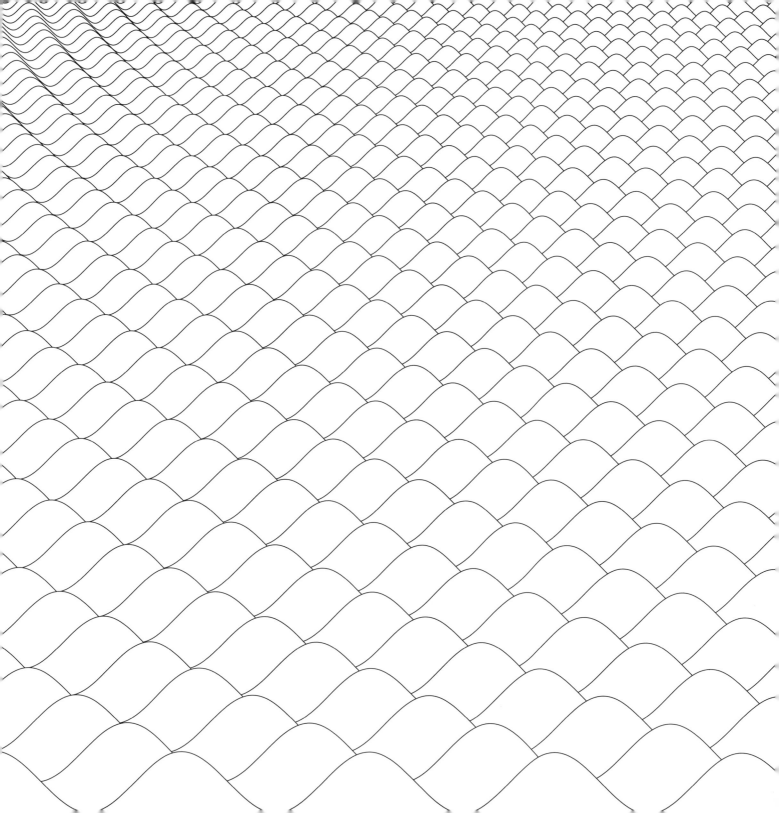

RIBBONS

A family of curves, each produced by the same formula, but using different input values. The effect is of a sine-like wave occurring both horizontally and vertically.

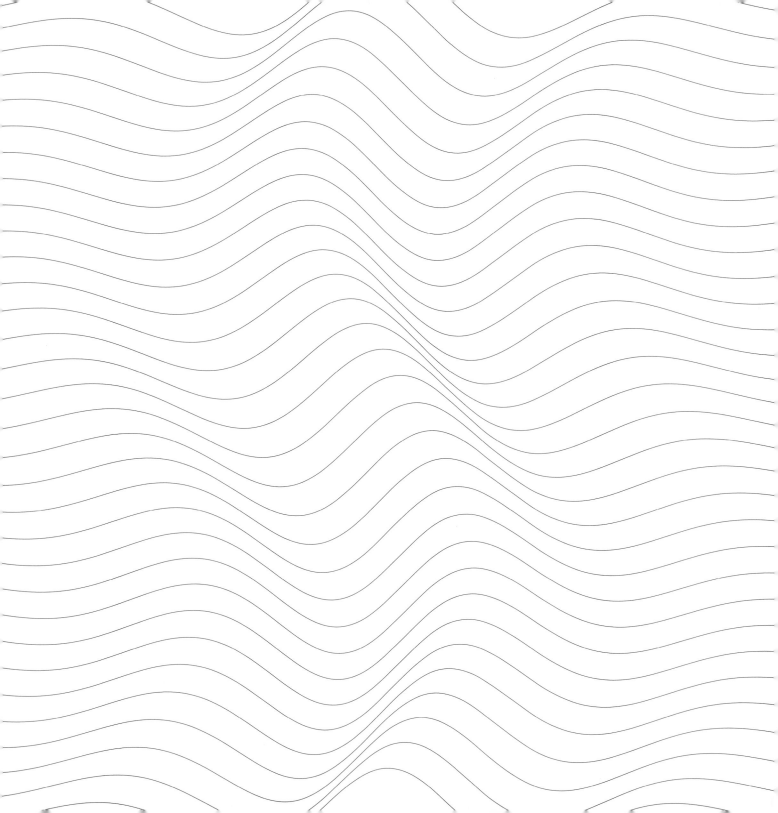

HOT SPOTS

A square grid of spots transforms into a billowing, polka-dot sheet. For those who want to try this at home, this image appears when every point (x, y) on the original grid moves to a new point, (1.5x + sin(y), 1.5y + sin(x)).

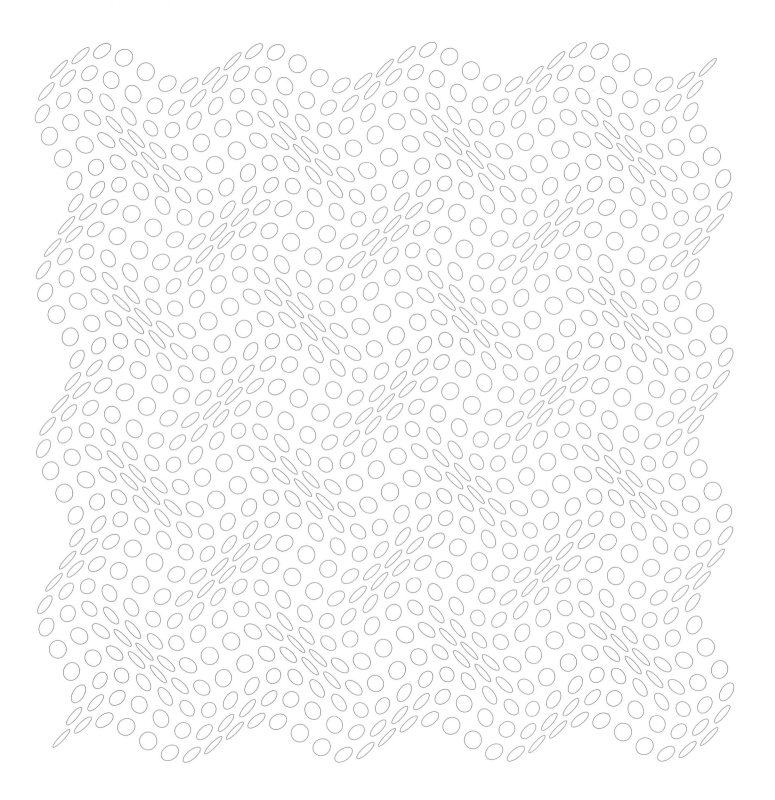

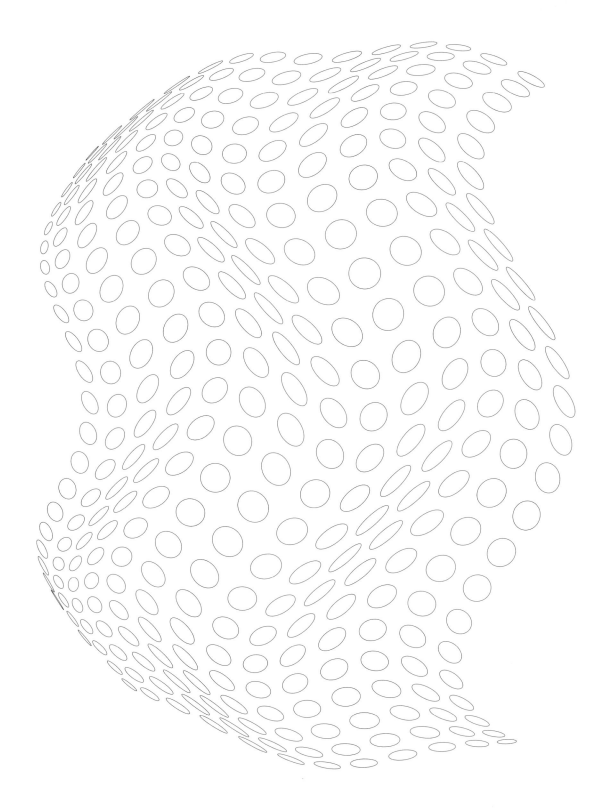

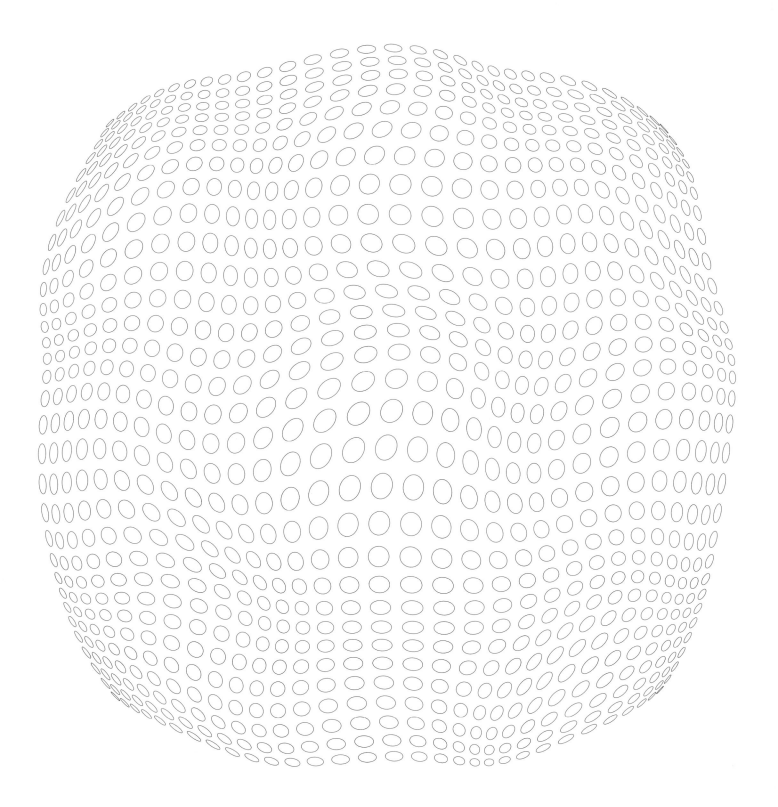

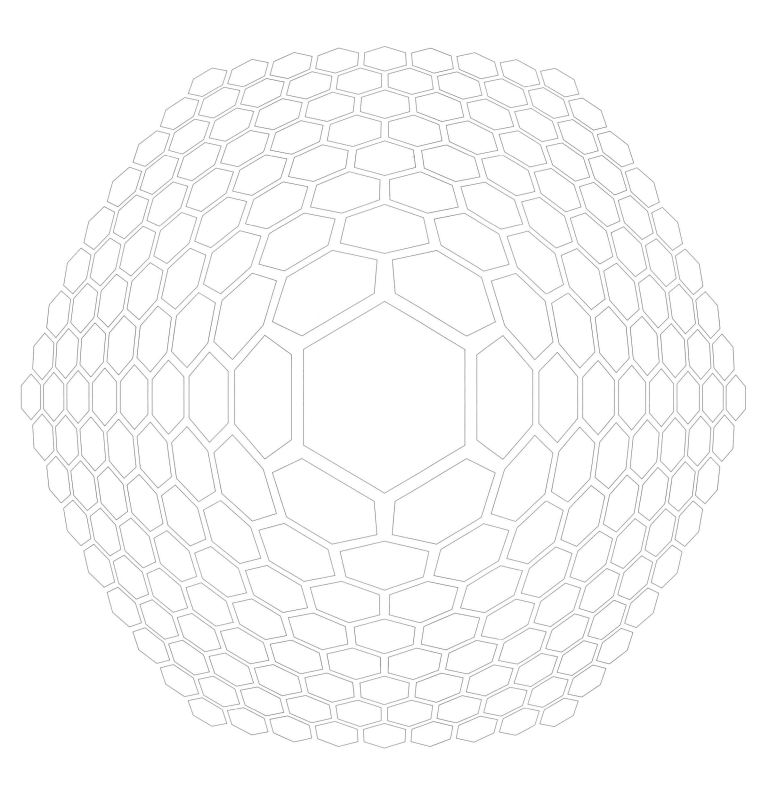

FRACTALS

Patterns that display self-similarity, meaning that the pattern is repeated on a smaller scale within the pattern itself

MANDELBROT SET

A detail of the Mandelbrot set, a fractal named after Benoit Mandelbrot, the French mathematician who investigated it in the 1970s. If you were to zoom in at any point on the intricate, wiggly line, the elaborate pattern would reappear infinitely.

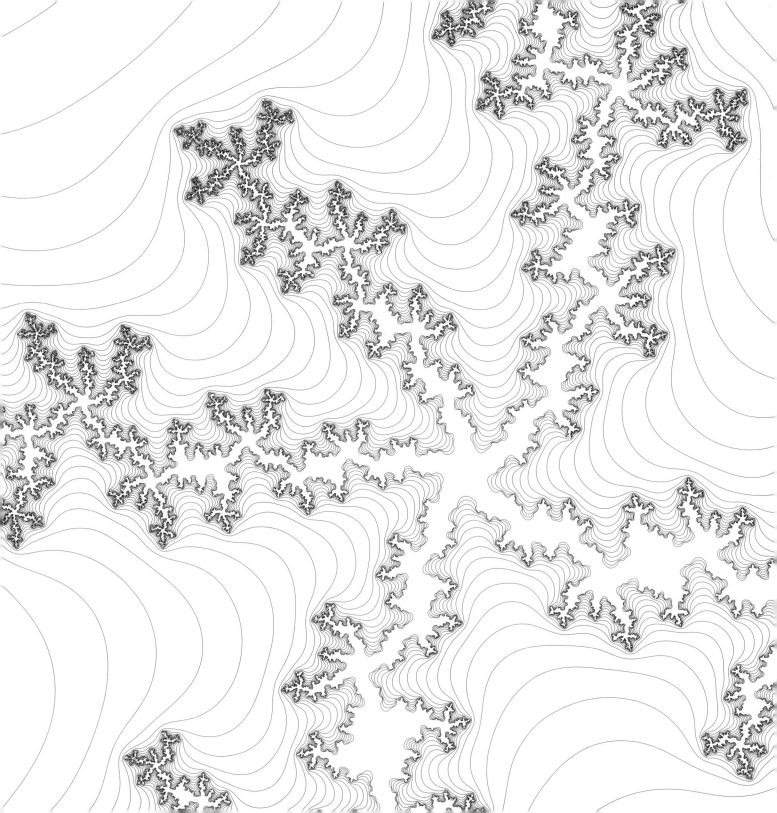

JULIA SET

This one is named after Gaston Julia, the French mathematician who in the 1910s developed the theory that leads to this type of fractal. It is constructed in a similar way to the Mandelbrot set.

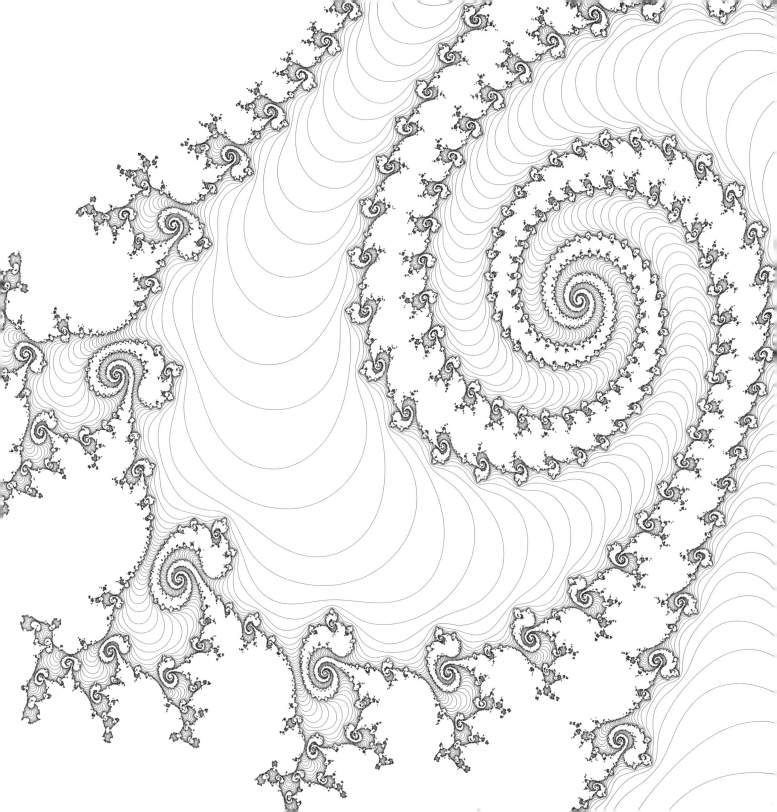

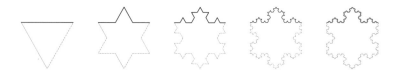

KOCH SNOWSTORM

The Swedish mathematician Helge von Koch drew his snowflake in 1904, one of the first fractal shapes to be described. The rule here is to replace every line section ——— with the line ⎯⋀⎯ as illustrated above.

If you start with a triangle, you get a six-pointed star. The next three steps follow. At right, several Koch snowflakes combine—a mathematical snowstorm!

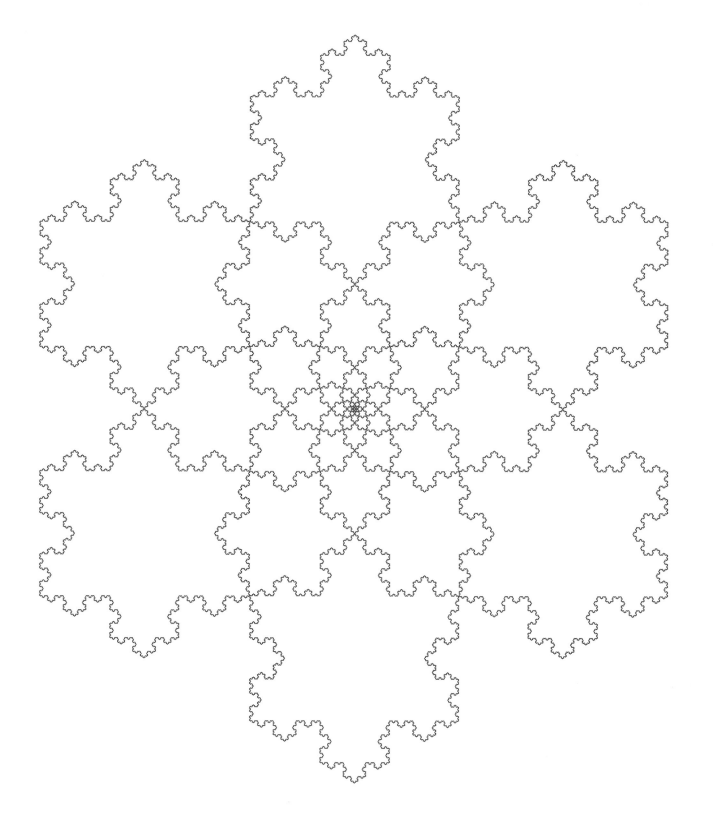

RAUZY FRACTAL

The tiles in this picture come in three different sizes, but they all have the same shape. In fact, you can put them together to build *bigger* versions of exactly the same shape, using 3, 5, 9, 17, 31, 57, 105, 193, 355, or (as here) 653 tiles. Gérard Rauzy discovered this tile in 1981. The boundaries look fuzzy because they have an infinite number of wiggles.

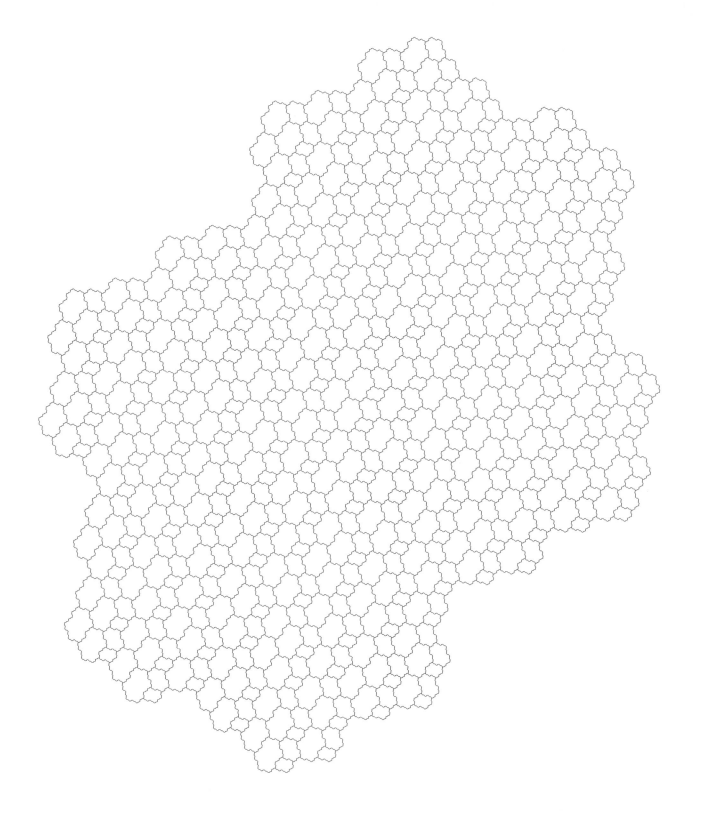

RAUZY PARALLELOGRAM

This is the straight-lined equivalent of the Rauzy fractal, where each size of tile is replaced by a differently-shaped parallelogram. You can think of it as a three-dimensional image. Imagine a block made up of rows and columns of identical small cubes. A flat plane cuts through the block diagonally, dividing the block into slice A and slice B. If you remove every cube that falls completely in slice A, the cubes that remain will look like this.

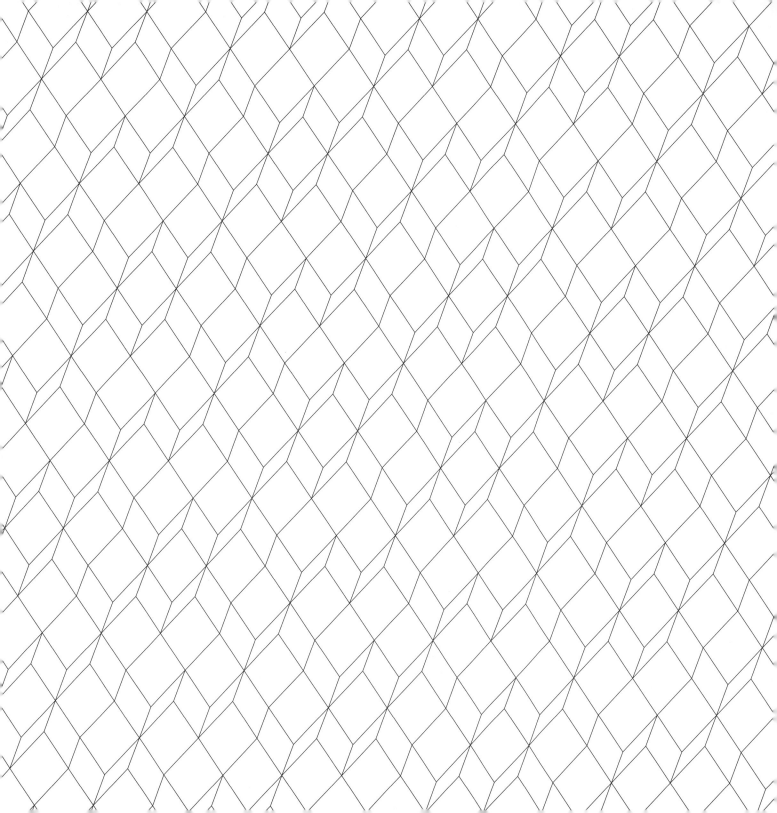

SPIRALING FLOWERS

Robert Fathauer is a former rocket scientist turned mathematical artist. One of his signature styles is to explore how you fit together tiles with the same shape but whose size is always changing. His website is www.mathartfun.com.

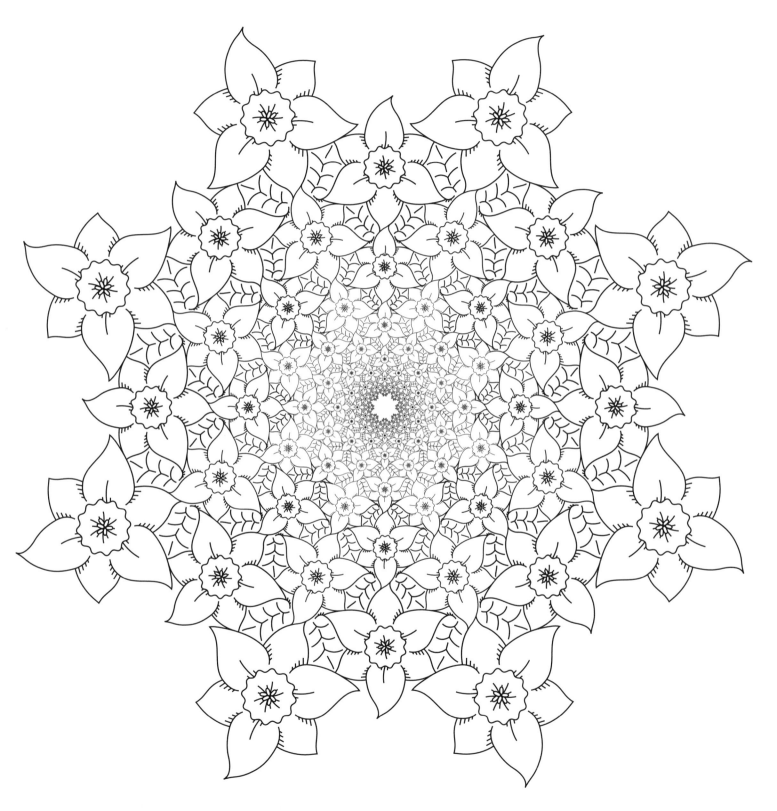

FRACTAL TILES

This is another fractal design by Robert Fathauer.

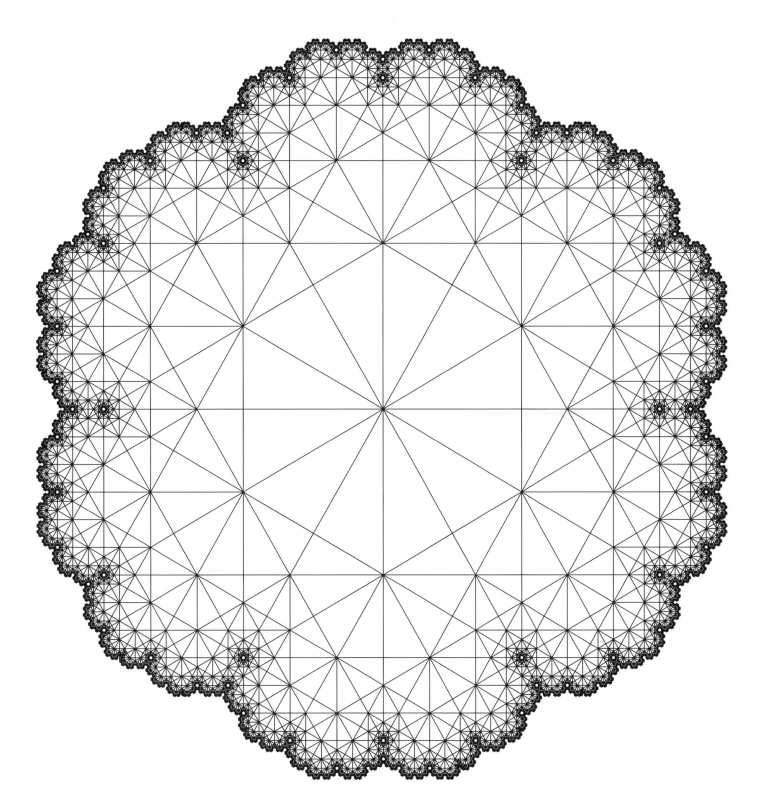

PERIODIC TILING

A tiling is an arrangement of tiles that leaves no gaps or overlaps

Periodic tilings have a repeating pattern. Imagine laying a piece of paper flat on the tiling and tracing the pattern. If you can slide the paper to another position so that the copy lines up perfectly with the original, then the tiling is periodic. The following examples use only one tile shape.

INTERFLOCKING BIRDS

This tiling is not only periodic, it has *rotational symmetry*. For example, if you rotate the pattern 180 degrees around any point where two birds are touching bellies, the rotated pattern will fit perfectly over the original. There are three more points along the outline of every bird where this is true. Can you spot them? The image is by David Bailey (www.tess-elation.co.uk).

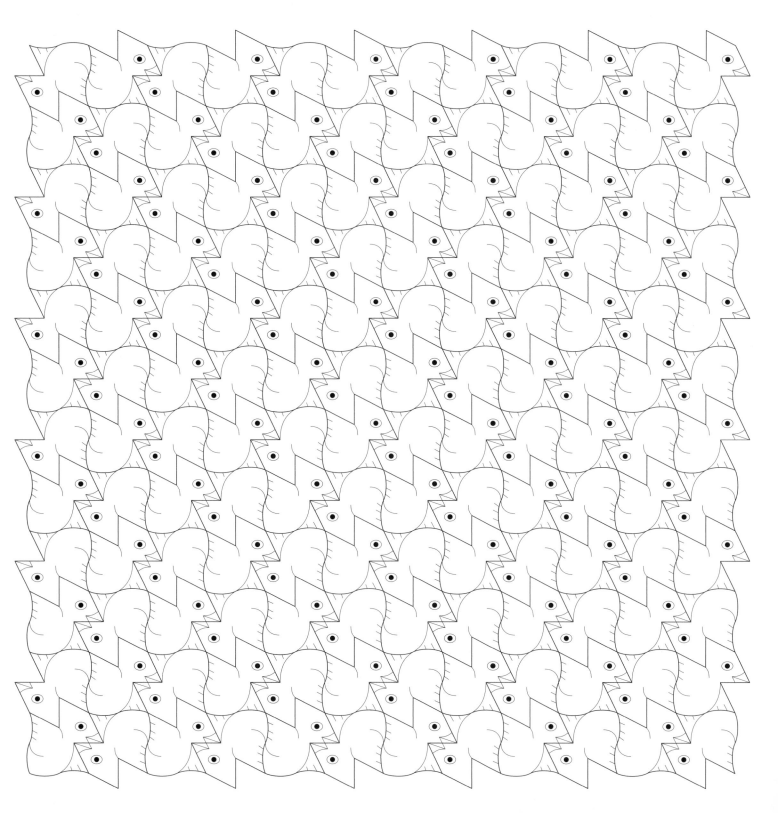

NESTED FISH

These fish tile with a different type of symmetry. If you reflect the pattern vertically, so right becomes left and vice versa, and then move it one row up or down, the new pattern fits over the original. This image is also by David Bailey (www.tess-elation.co.uk).

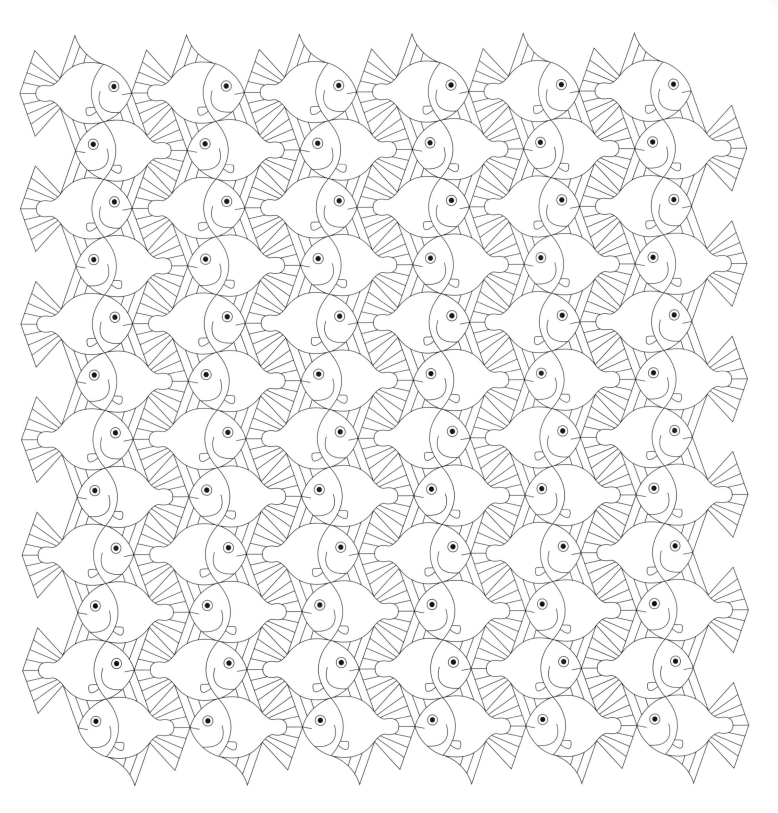

SNUG BUNNIES

This image is by Sam Kerr, a British graphic artist who has produced symmetric tiling patterns for fashion labels including Marwood and Paul Smith. His website is www.allfallin.com.

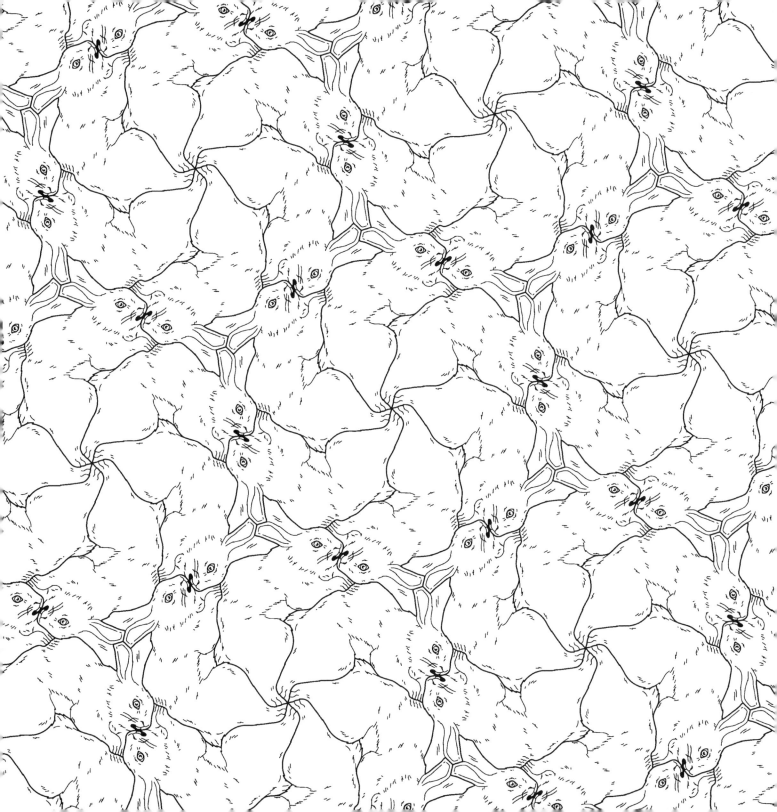

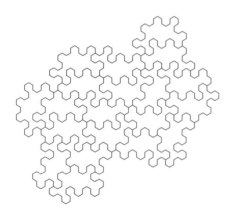

POLYHEX

Each of these tiles is a *polyhex*, a shape made up from identical hexagons, in this case 16 hexagons. Joseph Myers, who discovered the shape, proved that it requires a minimum of 20 such tiles to create a larger shape (above) that itself tiles periodically. No other known tile requires at least 20 to make a larger shape that tiles periodically.

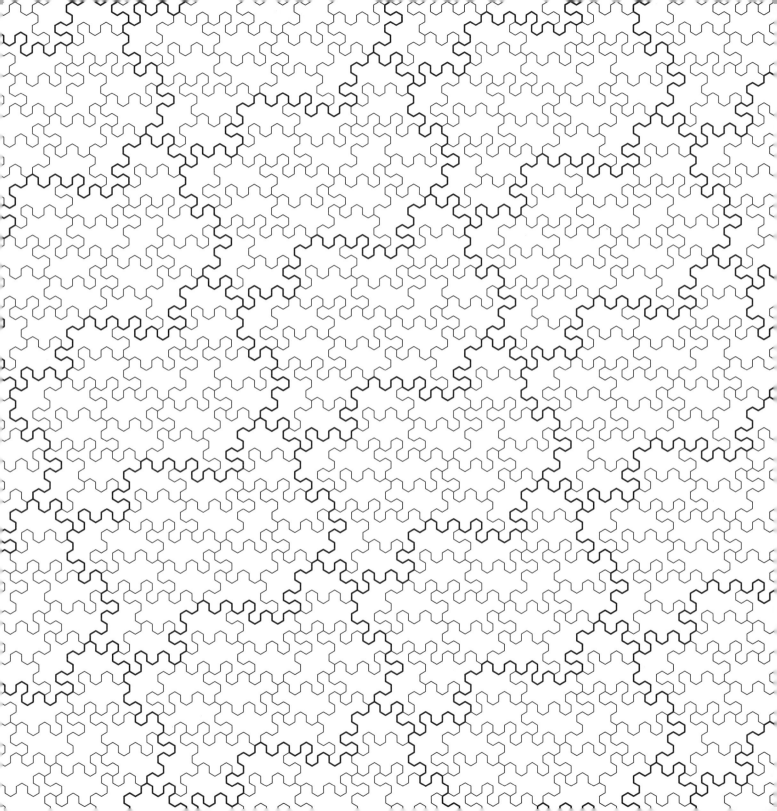

NON-PERIODIC TILING

A tiling is non-periodic *if you cannot shift the pattern to another position that fits perfectly over the original position*

PENROSE KITE AND DART

Many shapes can tile both periodically and non-periodically. In the 1970s Roger Penrose discovered sets of two shapes that tiled *only* non-periodically, or *aperiodically*. His most famous set of two aperiodic tiles are the kite and the dart, illustrated above. In order to tile aperiodically, the curved lines must match up where the kites and darts fit together.

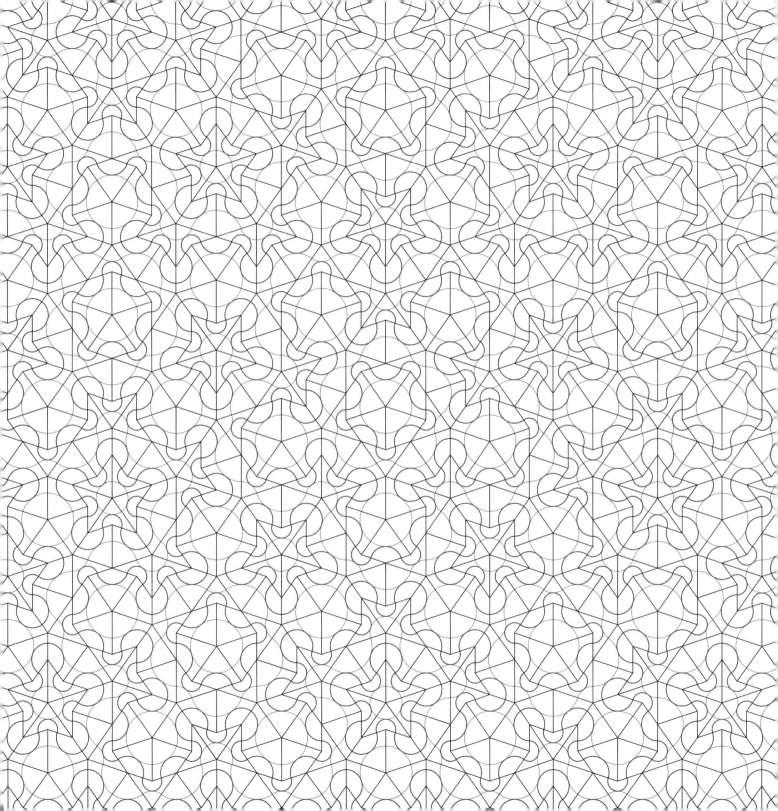

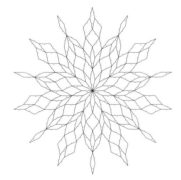

SEVEN-STAR

This pattern of three unique tile shapes—each a rhombus with a "nick" on each side pointing either in or out—was designed by Chaim Goodman-Strauss. It has sevenfold symmetry, meaning that you can rotate it around the center to seven different positions that look identical.

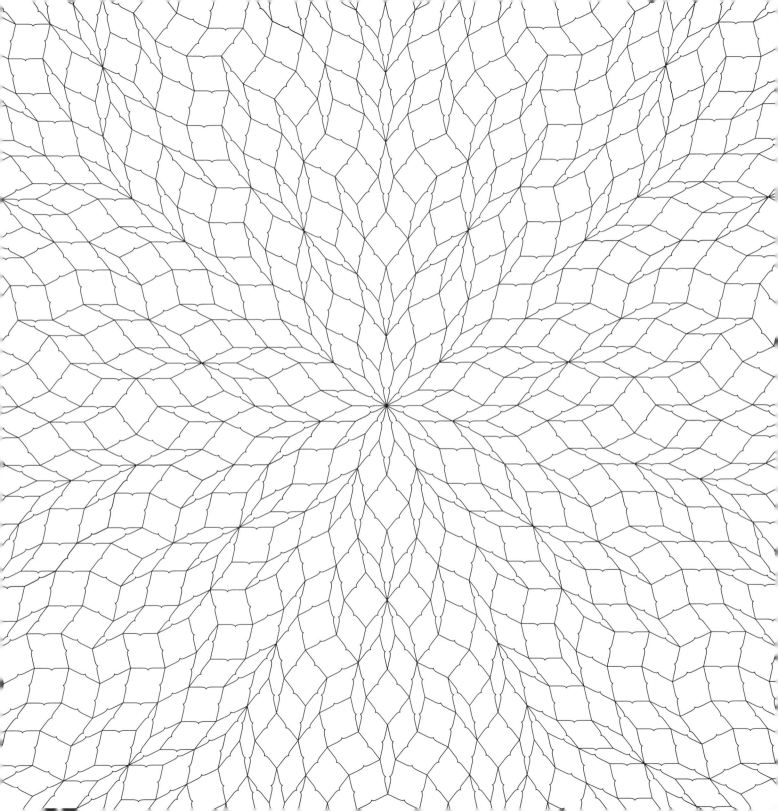

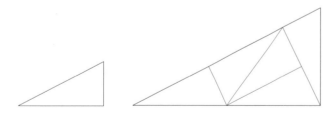

PINWHEEL

John H. Conway devised the pinwheel tile, a right triangle with hypotenuse √5 and side lengths 1 and 2. It has the amazing property that as you tile outwards the triangles will point in infinitely many directions. Every triangle is part of a set of five triangles that make a larger triangle with the same proportions. Can you spot them?

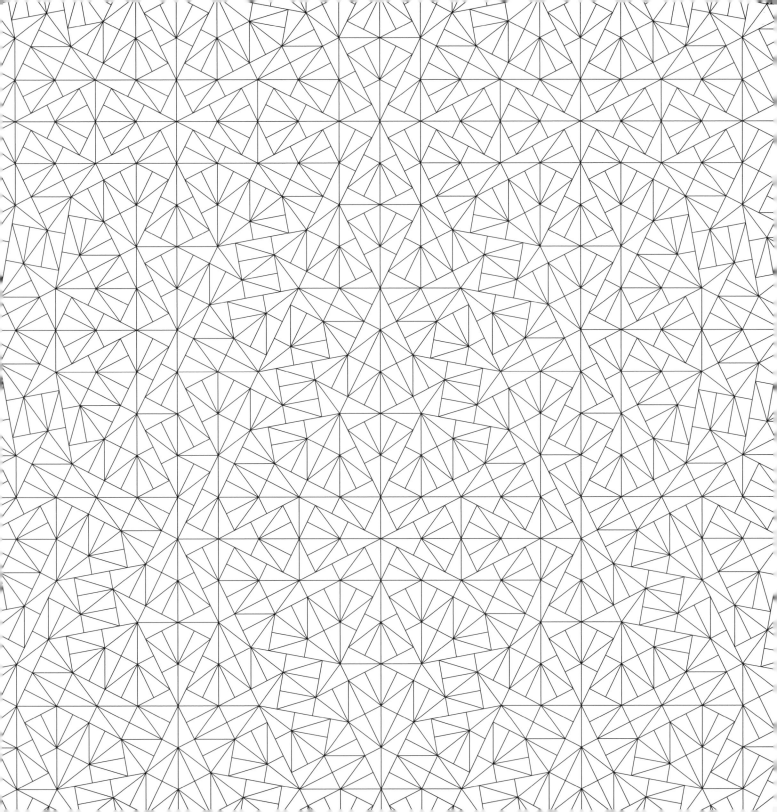

AMMANN-BEENKER

Amateur mathematician Robert Ammann was working as a mail sorter in a post office when he discovered this tiling, made from a square and a rhombus, which was independently discovered by the professional mathematician F. P. M. Beenker. The tiling is non-periodic and was later found to occur naturally in some types of crystal. It gives a striking three-dimensional effect when colored in.

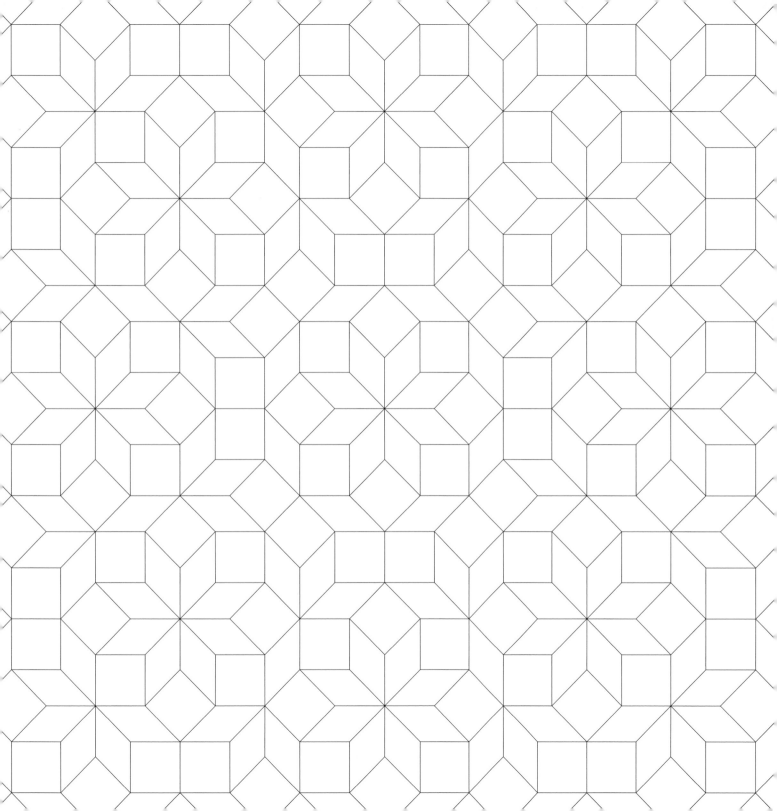

SPIRAL TILE

This single tile fills the whole plane by spiraling outwards. Try it out on an apple tart!

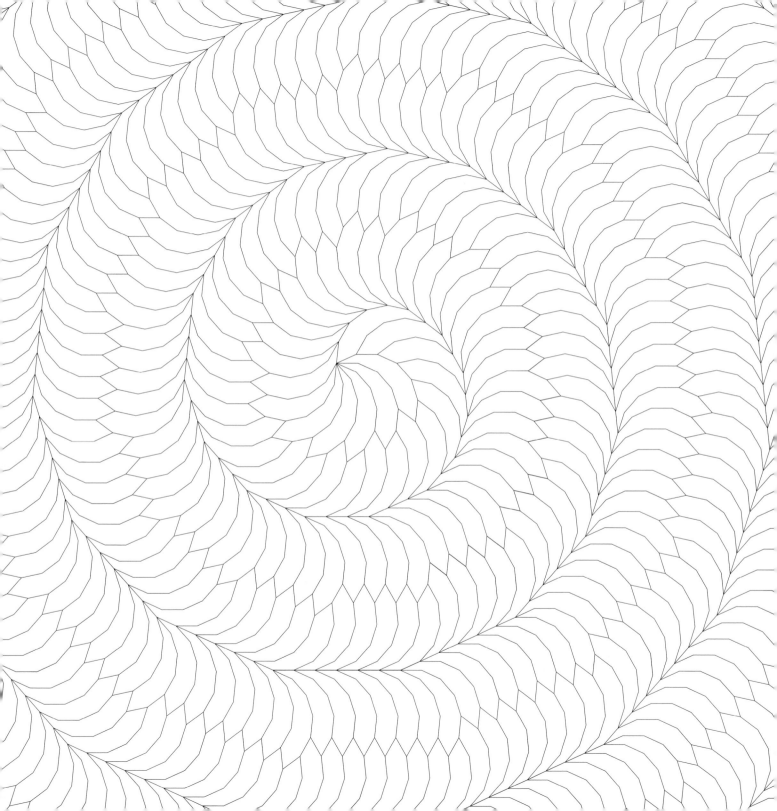

DE-FOUR-MATION

A *deformation* is a tiling in which the tiles slowly change while keeping the same underlying pattern. The earliest deformations, seen in the work of the Dutch mathematical artist M. C. Escher, morphed in a single dimension: from left to right, or from top to bottom. In this image, the deformation is two-dimensional. Edmund has created four different non-periodic tilings, one in each corner, that morph into each other from left to right *and* from top to bottom. Deformations are the nearest geometry gets to a "temporal" art form. You only get a feel for the pattern by following how the shapes shift across the page.

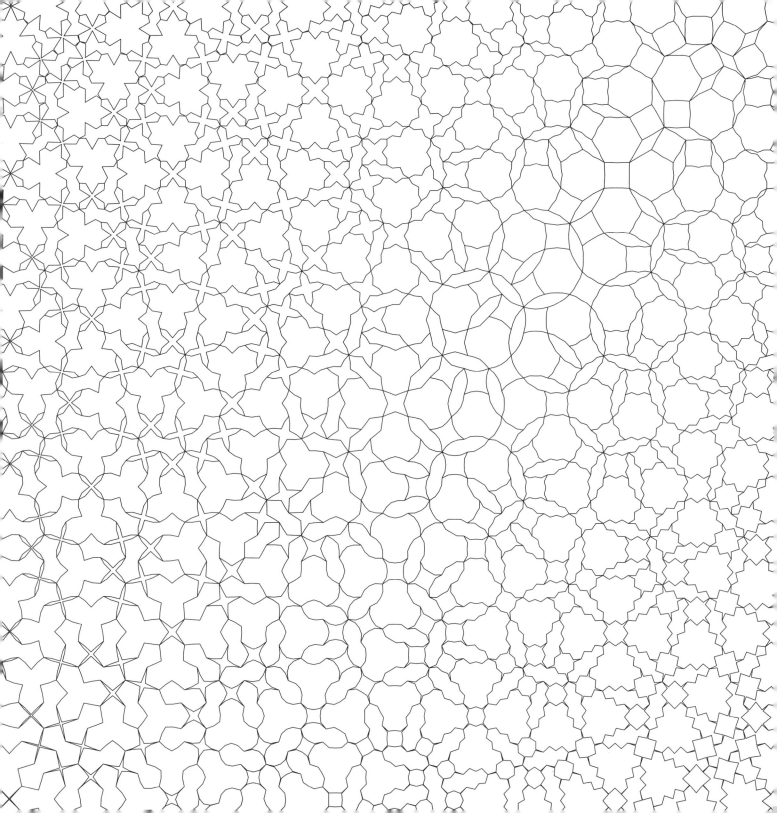

KNOTS

A mathematical knot is a closed loop of mathematical string

These are the seven simplest knots. A trefoil knot has three crossings. There is one type of knot with four crossings, two with five, and three with six.

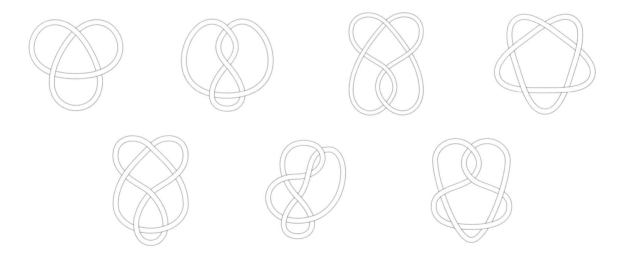

KNOT SIMPLE

At right, design your own knot by deciding whether the string passes under or over itself.

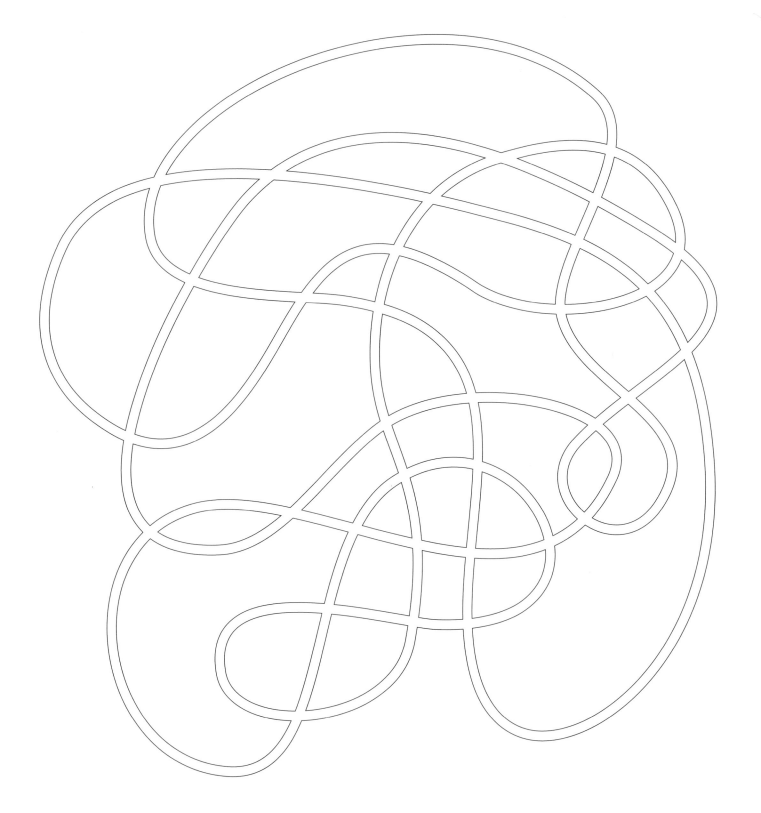

MECHANICAL CURVES

Curves drawn by machines

HYPOTROCHOID

Remember the Spirograph, the set of gears that is used to create decorative spirals? This image is a Spirograph-style curve made from rolling a circle of radius 21 around the inside of a circular track of radius 33, with the pen 8 units from the center of the rolling circle.

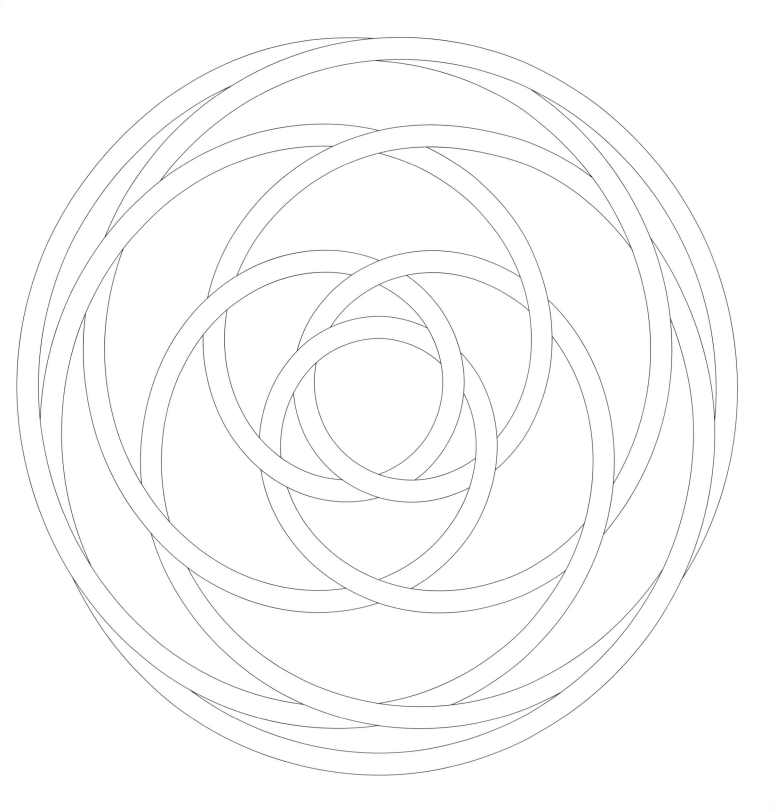

LISSAJOUS FIGURE

This looping curve—which looks like a Celtic knot—is produced by a machine that swings a pen back and forth in two perpendicular directions at the same time. Here the ratio of north-south to east-west swings is 5 to 6. Curves drawn by perpendicular oscillations are called *Lissajous figures*, named after the French mathematician Jules Antoine Lissajous.

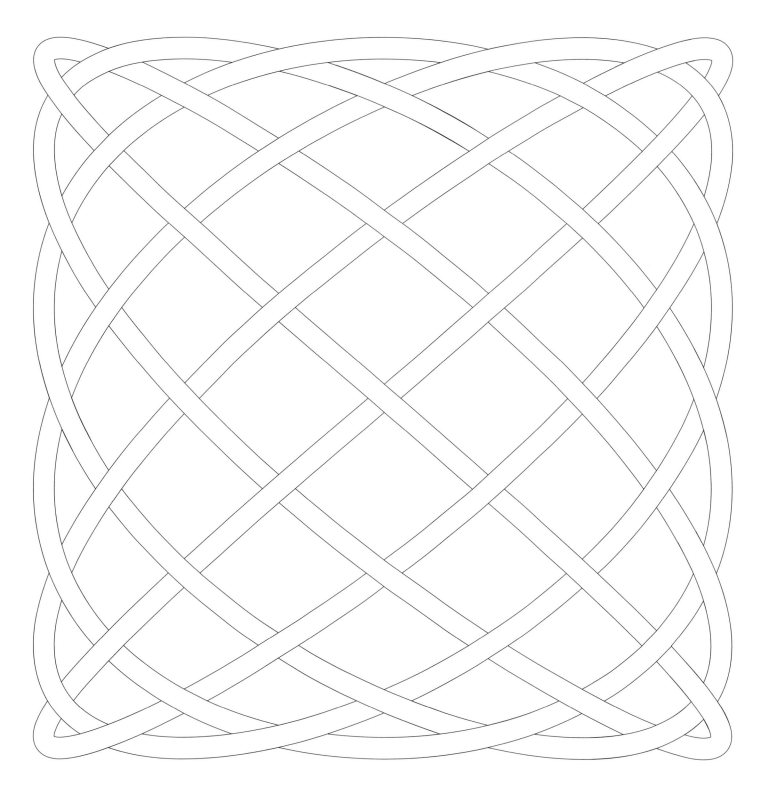

POLYHEDRA

Three-dimensional solids made out of polygons

A *polygon* is a two-dimensional shape with straight edges—like the triangle, the quadrilateral, and so on. A polygon is *regular* if all the sides and all the angles are equal—like the equilateral triangle, the square, and so on.

A *polyhedron* is a three-dimensional shape built from polygons. These are the only five polyhedra whose faces are identical regular polygons and for which the same number of faces meet at each vertex:

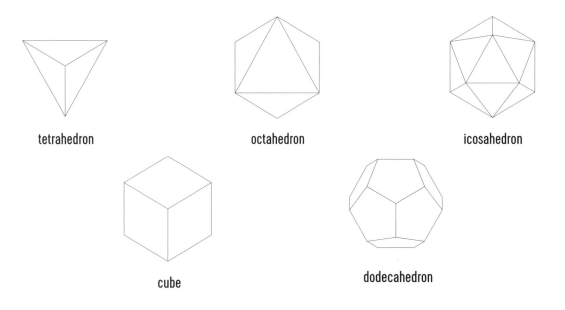

tetrahedron

octahedron

icosahedron

cube

dodecahedron

TETRAHEDRON STAR

A symmetrical way to overlap five tetrahedrons. If you join the tips together you make a dodecahedron.

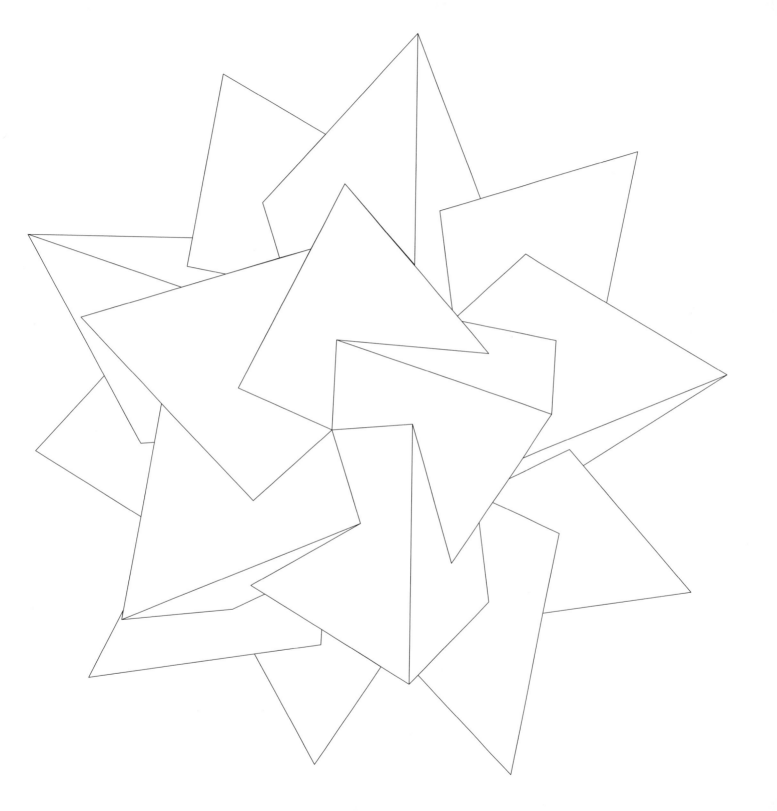

STELLATED AND SNUBBED

These two shapes start with the dodecahedron (above). Extending each face into a five-pointed star creates the *stellated* dodecahedron. This can also be thought of as adding a pyramid with a pentagonal base to each face.

Surrounding each face with triangles creates the *snub* dodecahedron. The snub dodecahedron is one of the 13 *Archimedean solids*, which are the polyhedra studied by Archimedes made up from different regular polygons meeting at identical vertices.

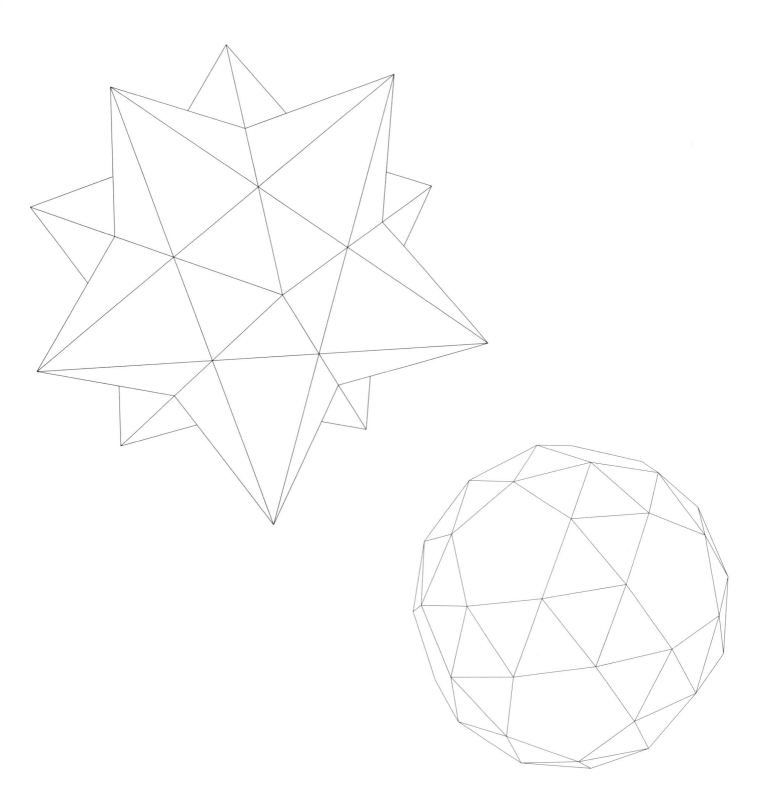

CRAZY DICE

Crazy names too! The *trapezoidal icositetrahedron* (24 sides) and the *trapezoidal hexecontahedron* (60 sides) have identical trapezoids as faces and would therefore make perfectly good dice.

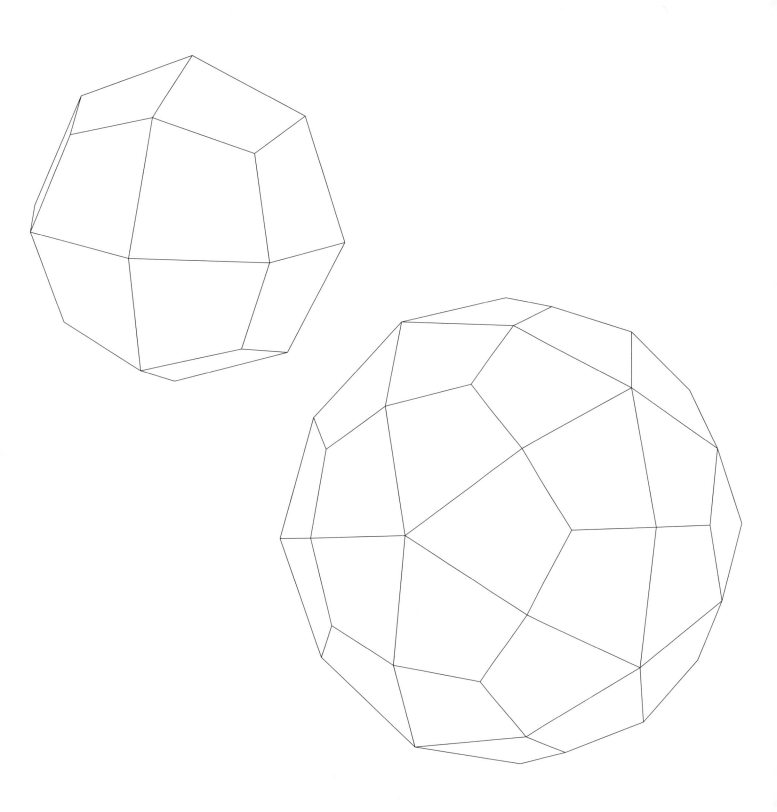

ICOSAHEDRON MAP

Computer programmer Roice Nelson drew lines on an icosahedron, and then mapped the 3-D surface onto the flat page. Usually, he likes to make computer versions of Rubik's Cube—type puzzles (see www.gravitation3d.com/magictile).

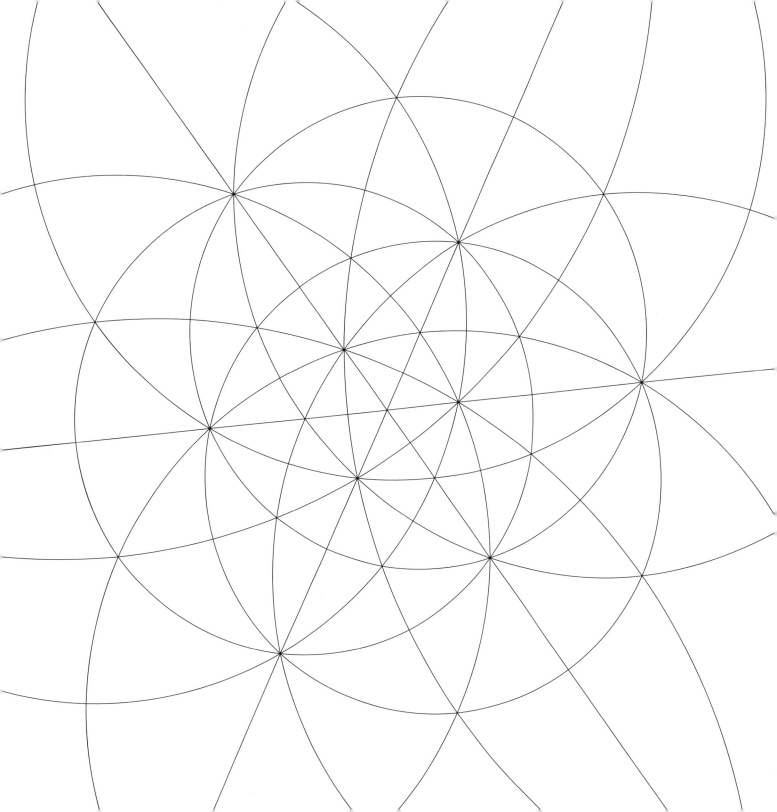

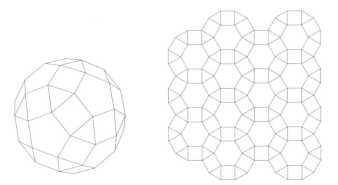

HEPTAGON TILING

The 3-D solid above left, made from pentagons with a square on each edge and a triangle on each point, is called a *rhombicosidodecahedron*. (No, I can't pronounce it either.) If you swap the pentagons for hexagons, you get the lovely tiling above right.

Now swap the hexagons for heptagons. The new pattern won't tile a flat plane . . . but it *will* tile a curved plane—in what we call *hyperbolic space*. One way to draw this new geometry on a flat page is the *Poincaré disc model*, in which the tiles appear smaller farther from the center (although in hyperbolic space they are all the same size).

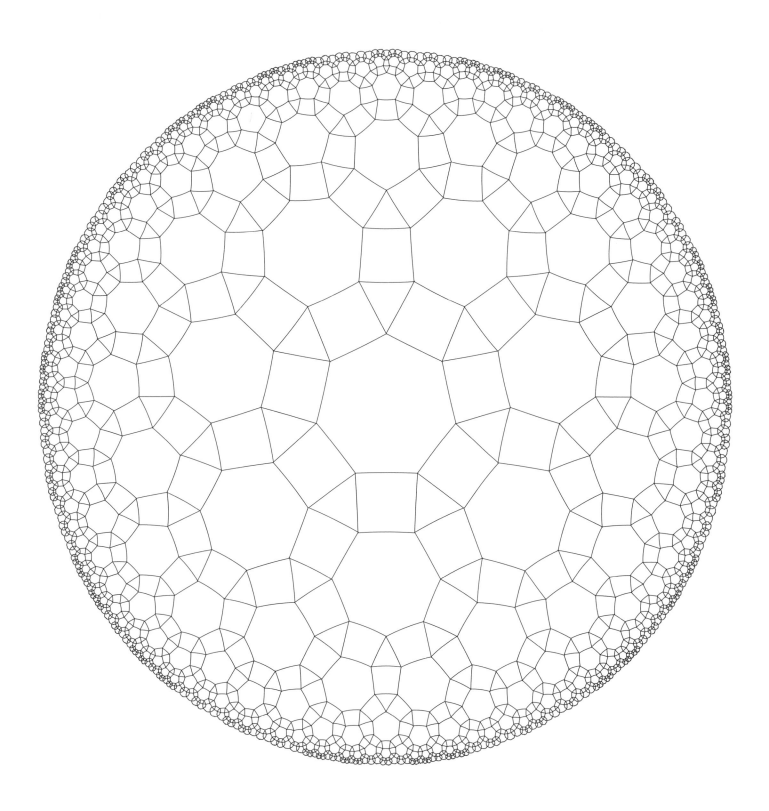

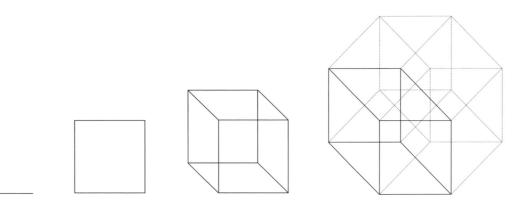

HYPERCUBE

In one dimension, we have a line. In two dimensions, a square with four straight sides. In three dimensions, a cube with six square faces.

A cube in four dimensions—the *hypercube*—has eight cubic faces. But since we can't visualize four dimensions, we can only see the hypercube's "shadow" in either two dimensions (as here) or three. The eight cube faces are seen flattened in the image. Above, one is highlighted in bold.

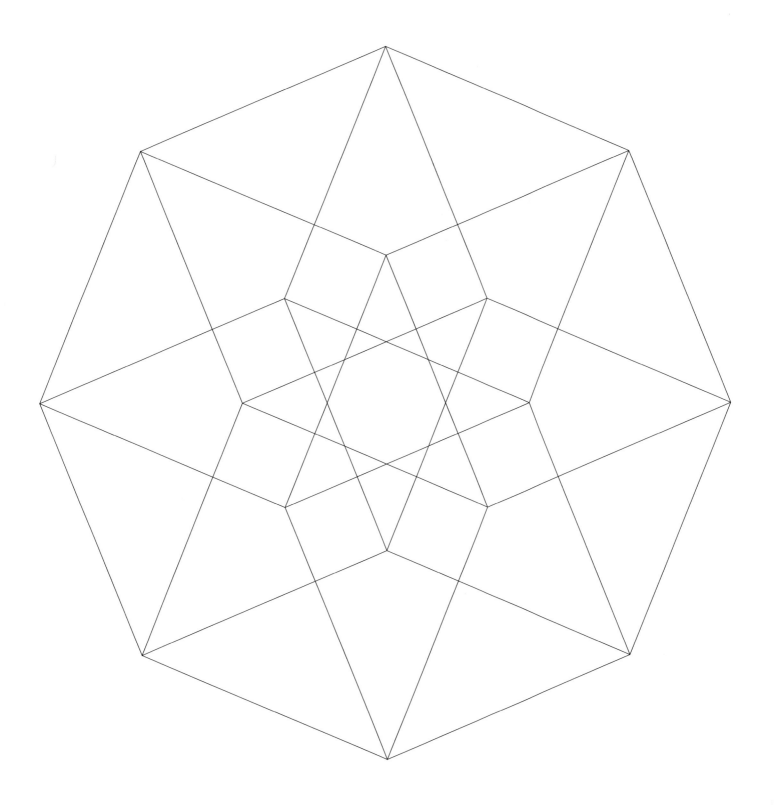

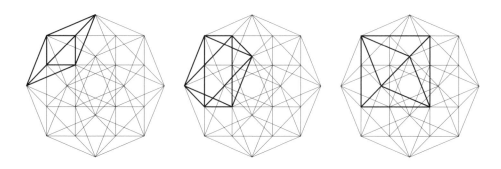

OCTAPLEX

The *24-cell*, or *octaplex*, another four-dimensional shape, has 24 octahedrons as faces. This image is its shadow in two dimensions. The 24 flattened octahedrons come in three "families"; above, you can see one of each in bold.

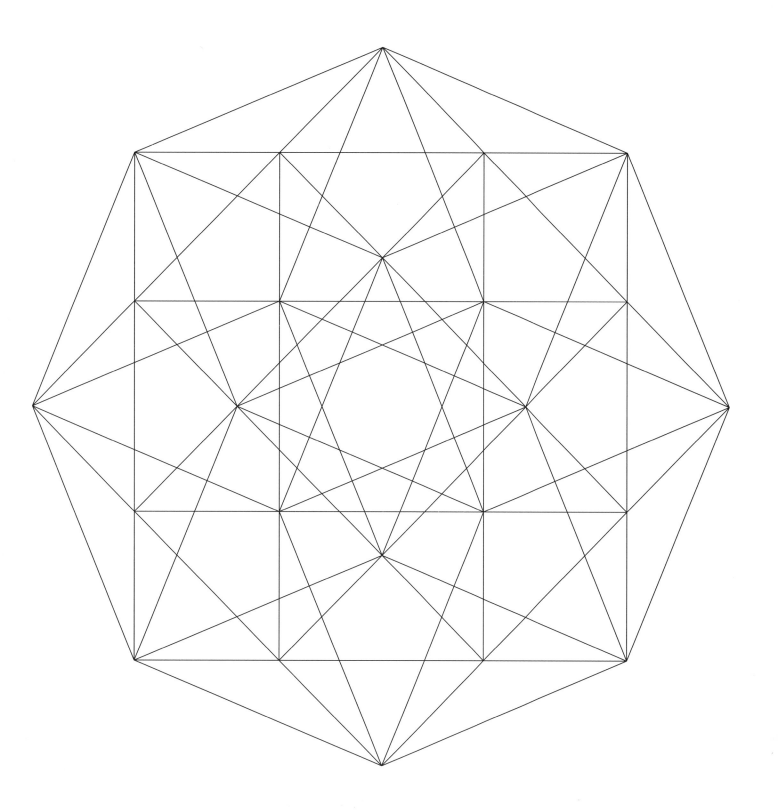

DODECAPLEX

The *hyperdodecahedron*, or *120-cell*, is a four-dimensional shape with 120 dodecahedrons as faces. Here are two different 2-D shadows, each depending on the angle of projection.

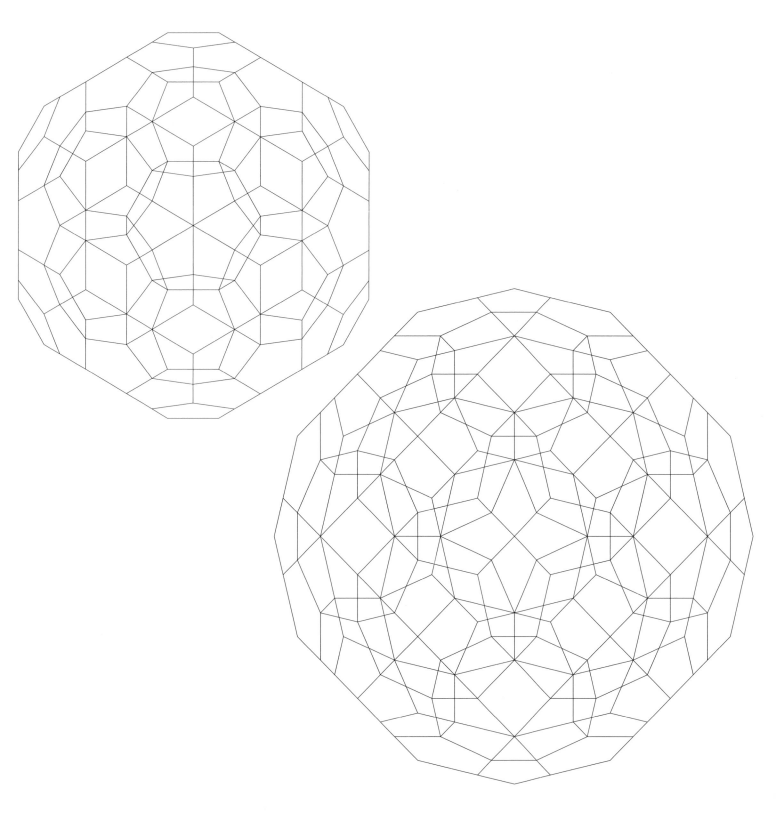

BRILLOUIN ZONES

Brillouin zones are a way of modeling the internal structures of crystals. The next two images are by Ron Horgan, professor of theoretical and mathematical physics at Cambridge University, who gives the following coloring suggestion: Choose a color for the central square, and another color for all the shapes sharing a side with the square. All the shapes that share a side with *those* shapes are to be in a third color, and so on.

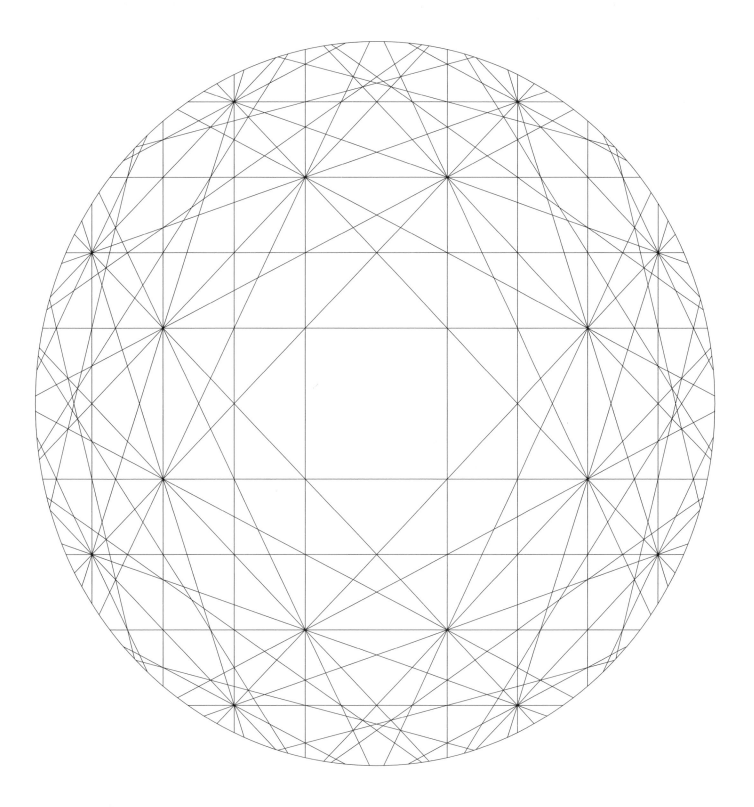

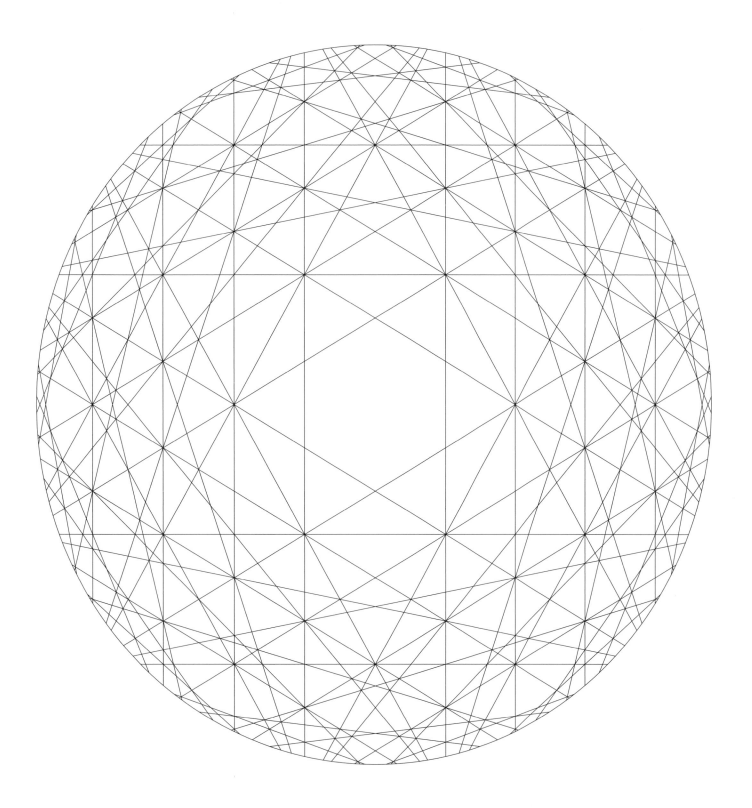

PROPORTION

Patterns with interesting ratios

SUNFLOWER

The *golden ratio* is the ratio (to three decimal places) 1.618 to 1. If you divide 360 degrees into two angles that are in the ratio 1.618:1, the smaller angle, 137.5 degrees, is known as the *golden angle*. Sunflowers are the most stunning manifestation of the golden angle in the natural world. The sunflower produces seeds from the center at consecutive angles of 137.5 degrees, which are pushed outwards as new seeds arrive. Here, the "seeds" are triangles.

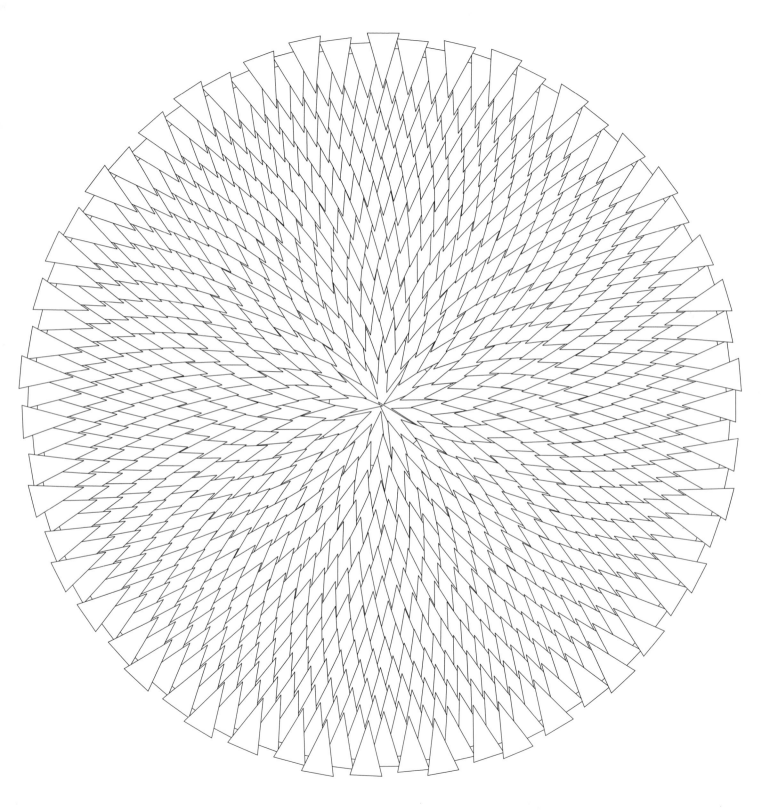

NAUTILUS

If you want to grow cells in a spiral so that each cell is bigger than the last—but always in the same proportion—you get a shape like the nautilus seashell. This type of spiral is also seen in sunflower seed heads, Romanesco broccoli, cauliflower florets, pinecones, cyclones, and galaxies. In this image, the cell width grows 1.4 times for every 90-degree turn of the spiral. Other ratios will create different manifestations of the spiral.

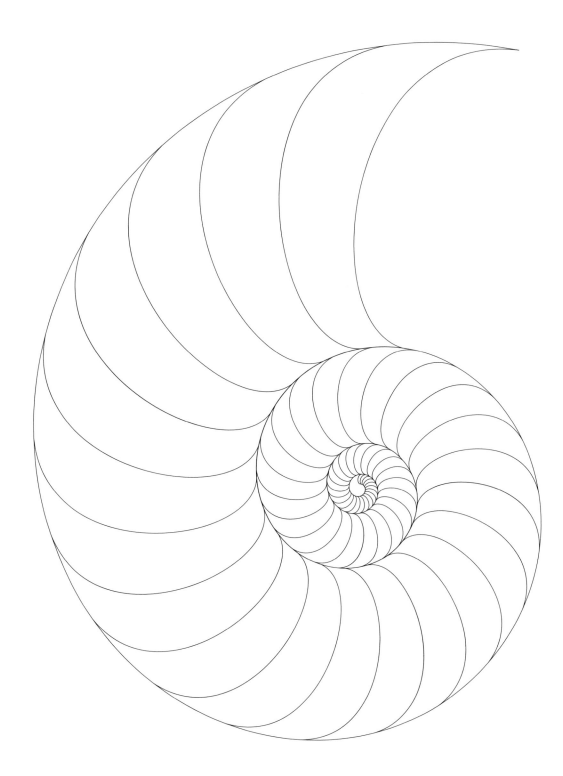

GOLDEN RECTANGLES

The *Fibonacci sequence*—1, 1, 2, 3, 5, 8, and so on—follows the rule that each new term is the sum of the previous two. So, 1 + 1 = 2, 1 + 2 = 3, and so on. The side lengths of the squares in this image follow the Fibonacci sequence. Let's say the smallest squares have length 1. They come in pairs. A square of side 2 is positioned next to them, to make a rectangle. A square of side 3 is positioned next to that rectangle, making a larger rectangle. Then comes a square of side 5, and then one of side 8, and so on. Each time we add a square, the ratio between the sides of the rectangle we're building gets closer to the golden ratio, 1.618, so these are commonly called *golden rectangles*.

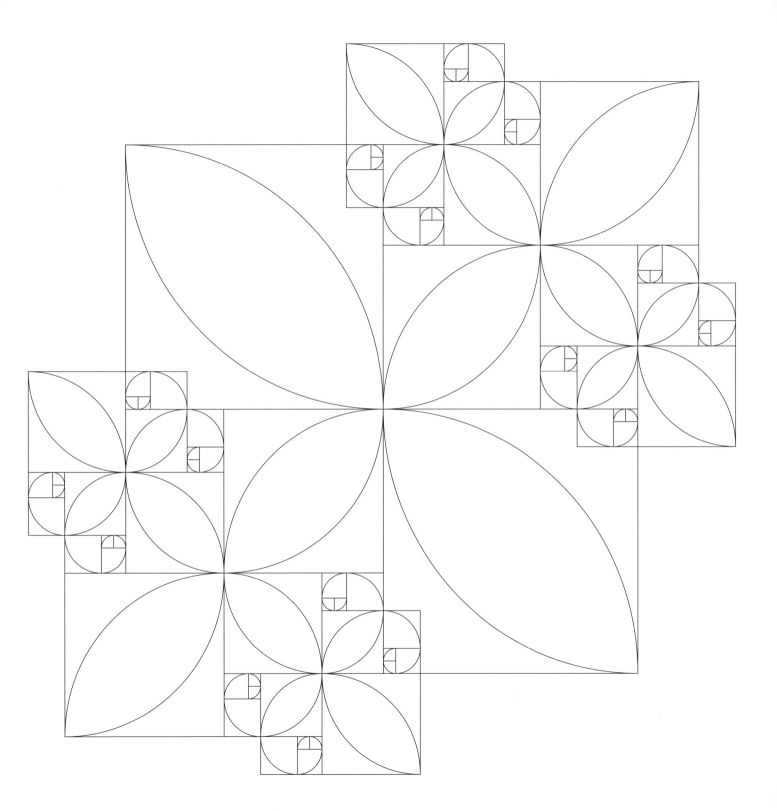

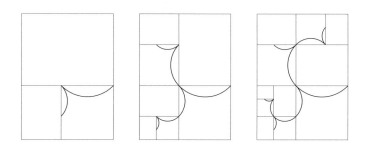

HARRISS SPIRAL

Edmund started with a rectangle and divided it into three shapes: two smaller rectangles with the same proportions as the original, and a square. Then he divided *those* rectangles the same way, and so on. This is the resulting spiral—and Edmund's most cherished discovery!

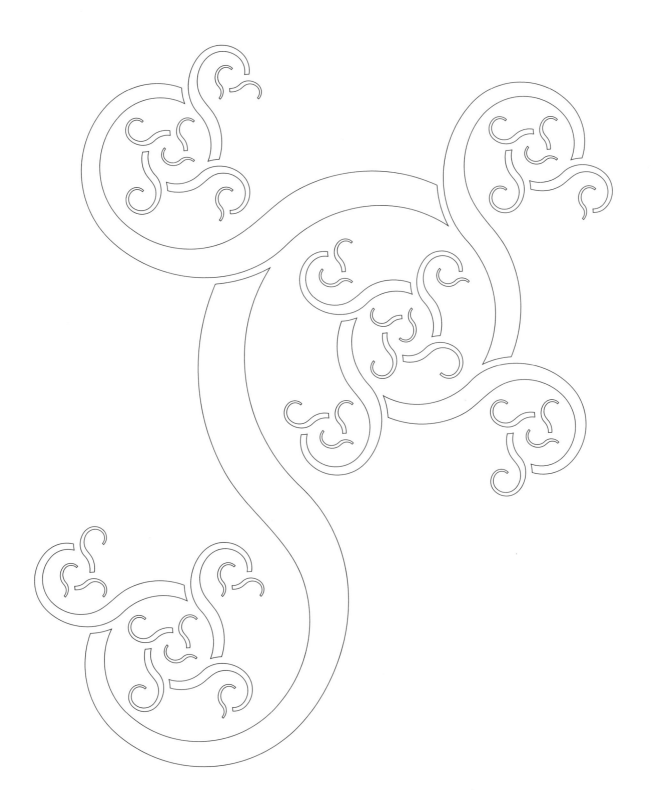

SQUARED SQUARE

A square divided into smaller squares, where the side length of each sub-square is a whole number

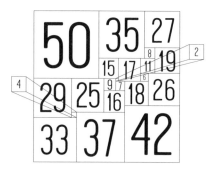

PERFECT SQUARE

In a "perfect" squared square, each sub-square must have a different size. In 1978, A. J. W. Duijvestijn discovered a perfect squared square made from 21 sub-squares. No other perfect squared square has fewer sub-squares than this one. The diagram above indicates the side length of each square.

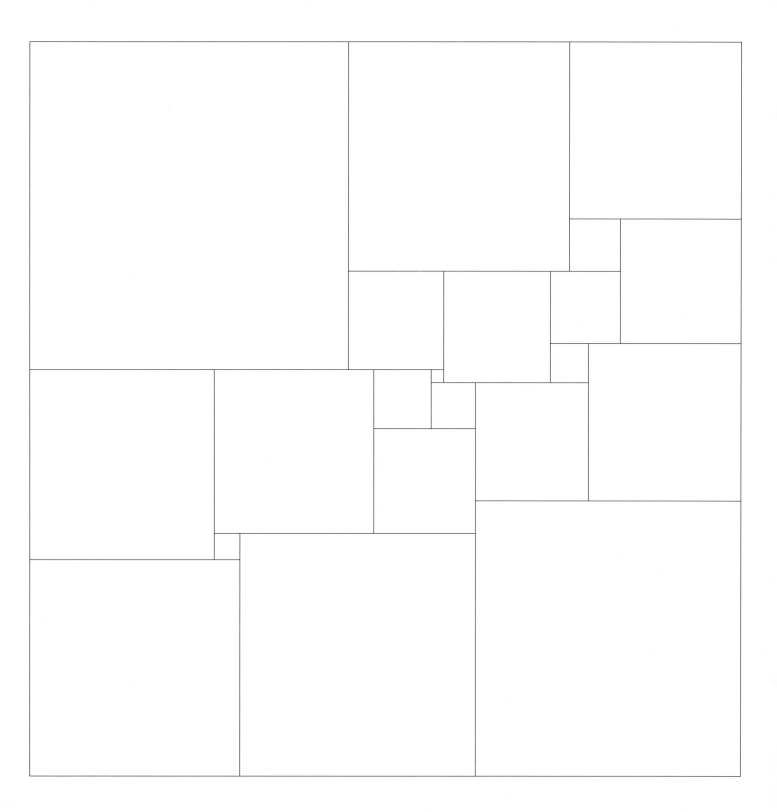

CO-PRIME NUMBERS

Two numbers are co-prime, *or* relatively prime, *if 1 is the only number that divides both of them*

CO-PRIME GRAPH

Four and 9 are co-prime, but 4 and 10 are not co-prime since they are both divisible by 2. This image shows a coordinate graph where dots are marked only where the coordinates (x, y) are co-prime. So (4, 9) is marked, but (4, 10) is blank. The leftmost circle in the bottom row is (1, 1).

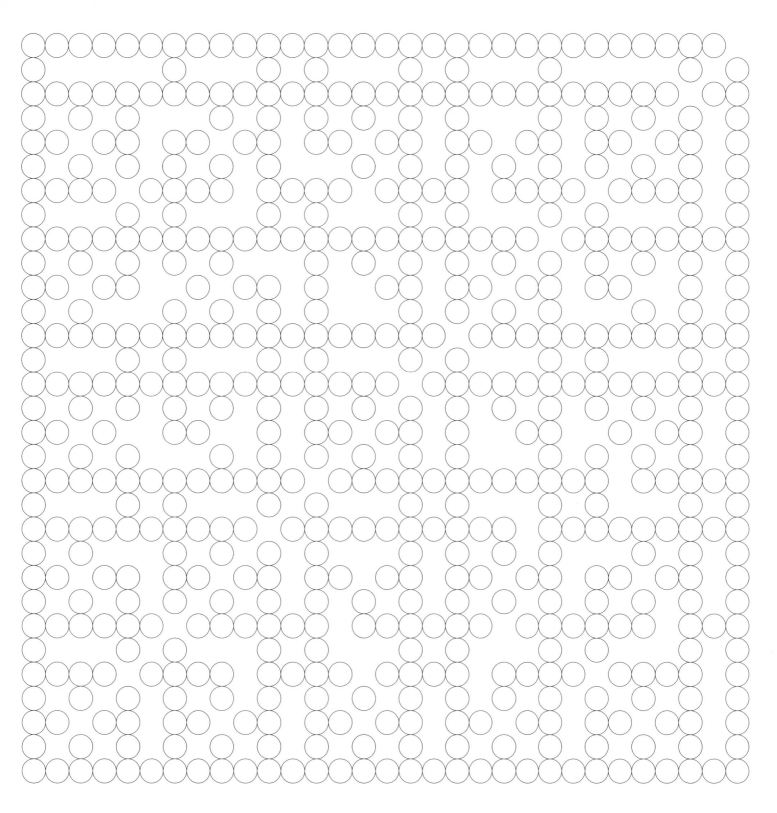

RANDOMNESS

Patterns based on random choices

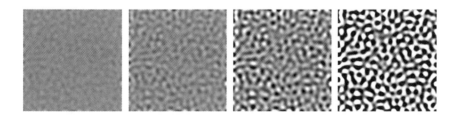

PRIMORDIAL SOUP

Every pixel is randomly assigned a level of greyness, and then the image is repeatedly put through first a filter that blurs and then one that sharpens. Gradually interesting shapes emerge.

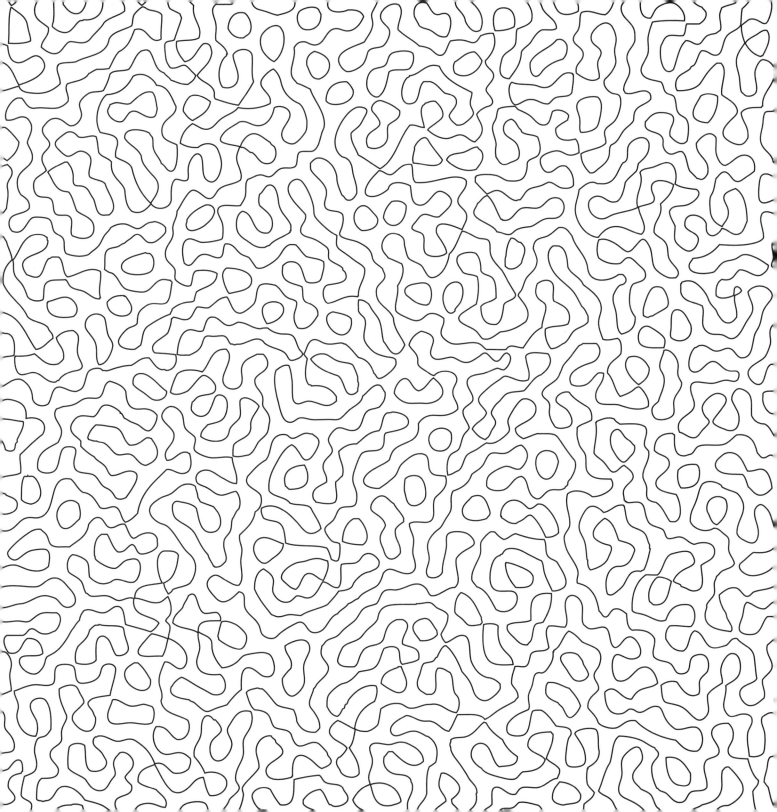

CRAZY MAZE

We started with a grid of squares, and then randomly assigned each square one of the tiles above. The result is a simple maze.

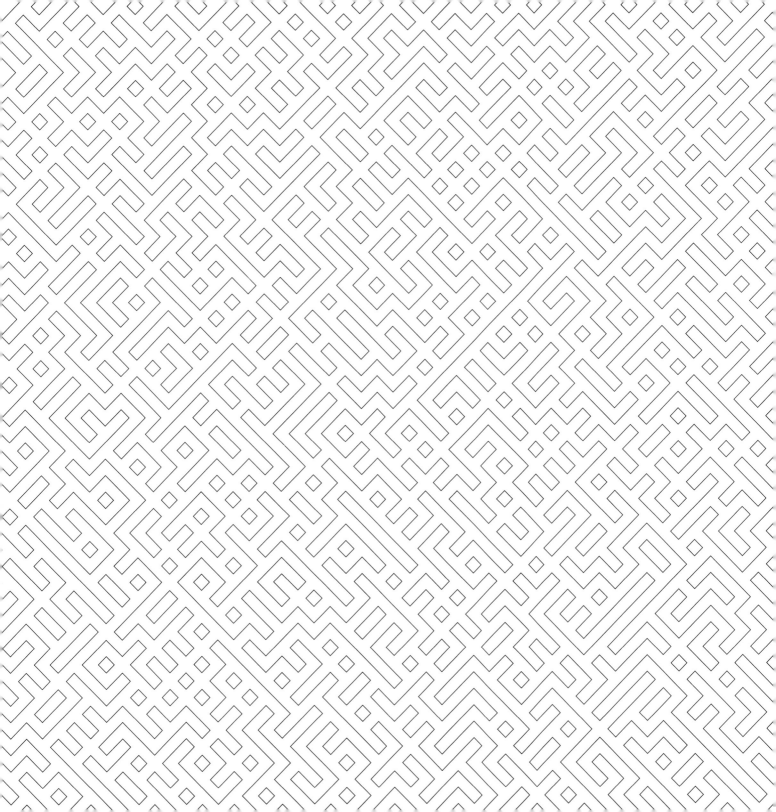

SPACE-FILLING CURVE

A curve that will eventually fill a region of the plane

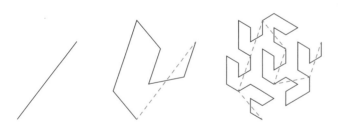

TRIPLE FLOWSNAKE

Start with a line and replace it with a zigzag of six smaller lines, as illustrated above. Now replace each of *those* lines with the same zigzag (using two zigzags for the longest line). Do this once more and you have a wiggly curve, three of which joined together make this image. The curve, called a "flowsnake," was discovered by Bill Gosper.

There's no limit to how many iterations of zigzags you can perform on this curve. The more iterations you do, the longer the curve becomes. After an infinite number of iterations, the curve will cover every point within a region of the plane.

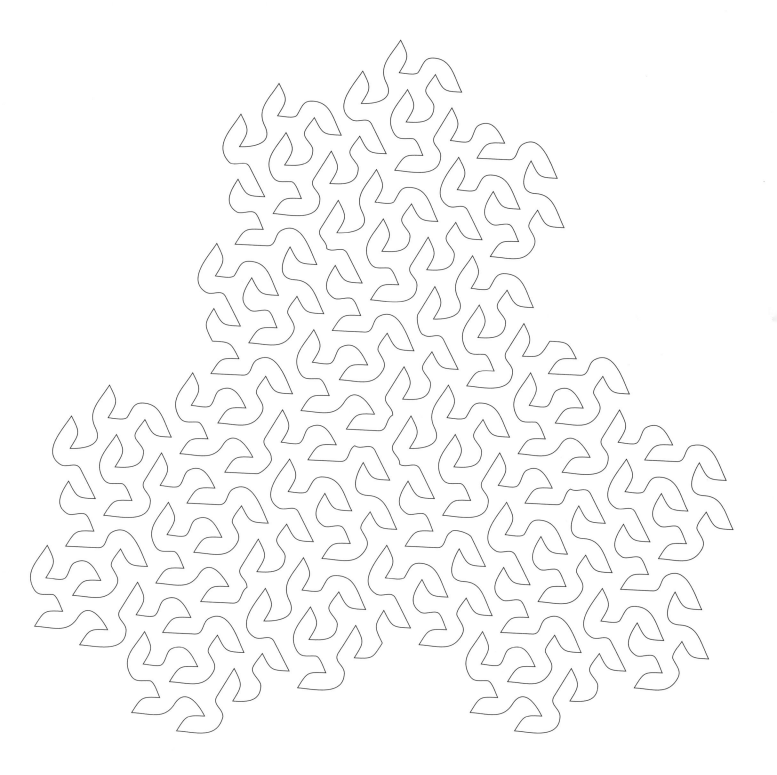

VENN DIAGRAM

A Venn diagram shows every possible overlap between two or more sets

SEVENN

A Venn diagram with three sets is three overlapping circles, illustrated above. To include all possible intersections of more than three sets, we have to use other shapes. The five-set Venn diagram uses ellipses. The seven-set Venn diagram requires a very peculiar shape that looks like a squid or a ghost. Above, we have bolded just one of them.

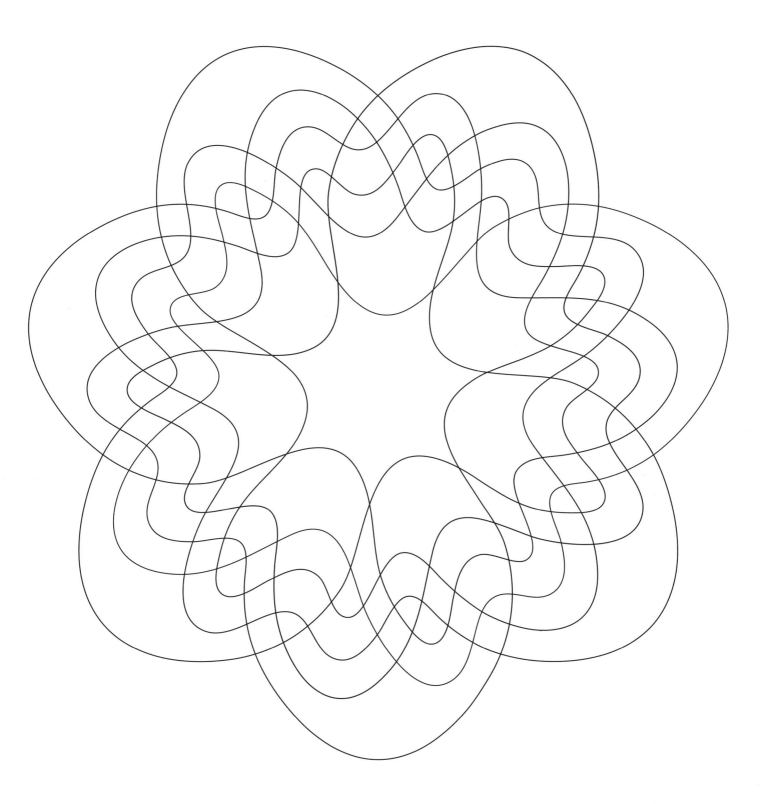

CREATING

RANDOMNESS

Patterns based on random choices

COIN HEX

For each hexagon, toss a coin to determine the color. Choose one color for heads, one for tails.

The point here is that you will have colored the hexagons totally randomly. But stare at it and you will see patterns. It's a reminder that we find randomness very difficult to comprehend.

DICE WALK

The digits 1 to 6 represent the six directions in the key (see right). Let them also be six colors. (You may find it easiest to start by coloring in the key.)

Start with a hexagon in the center of the grid. Roll a die. Move to the hexagon indicated by that digit and color it in. Repeat, and continue. If you land on an already colored hexagon, roll the die again.

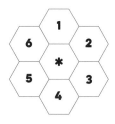

You wake up, drunk at a lamppost, and stagger a short distance in one of six directions. You collapse. You wake up again and stagger the same distance in one of six directions. The result is what is called a drunkard's walk or a random walk, and it is approximated here by rolling a die to decide which direction each time. The path will gradually go farther out from the lamppost but also, at times, double back. In fact, it is a mathematical certainty that a random walk will return to its starting point, although it may take many years and you may go on very large detours!

π = 3.14159265358979323846264338327950288419716939937510582097494459230781640628620899862803482534211706798214808651328230664709384460955058223172535940812848111745028410270193852110555964462294895493038196442881097566593344612847564823378678316527120190914564856692346034861045432664821339360726024914127. . .

PI WALK

The digits from 0 to 9 represent the directions in the key at right. Choose a color for each of them. Starting at the dot, draw a short line (about half an inch) for each of the digits in pi (given above) in the direction of that digit. So, start with the 3 color in the 3 direction, then continue from that point with a new line in the 1 direction in the 1 color, and so on.

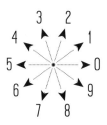

Everyone knows pi, the most famous number in math. It is the ratio between a circle's circumference and diameter (that is, between the distance around and the distance across). When written as a decimal, pi continues infinitely in a disordered mess of digits. Interest in pi comes from the fact that its definition is so simple, but the number is so untamed. This walk will give you a feel for the mysterious chaos of pi.

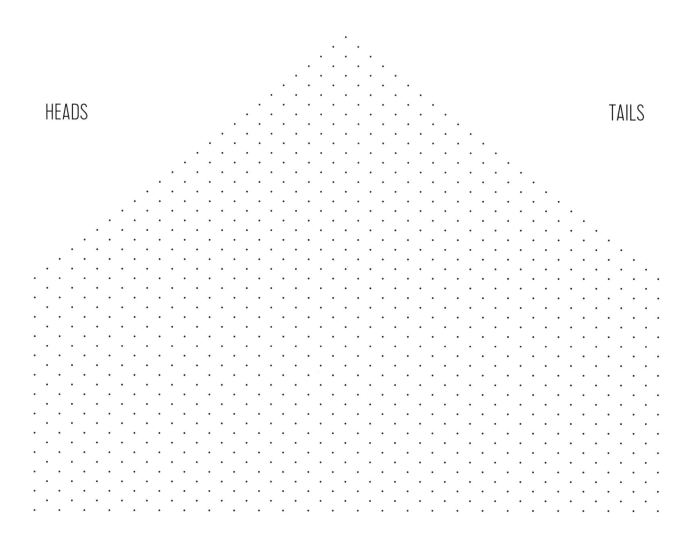

HEADS

TAILS

GALTON'S QUINCUNX

Start at the topmost dot. Toss a coin. Heads you draw a line to the dot below left, tails you draw a line to the dot below right. Toss again. Repeat until you reach the bottom. Then start from the top with a different color—as many times as you like!

Sir Francis Galton, the eminent Victorian scientist, designed a bagatelle machine, the quincunx, which consisted of horizontal rows of pins. Each row was offset from the one above it by half the distance between pins. A ball was dropped from the top and would bounce down to the bottom, hitting a pin in each row and falling randomly either to its left or to its right. Galton's purpose was to show the relative likelihood of many random paths.

LATIN SQUARES

Square grids where every object appears exactly once in every row and column

The sudoku is the most famous type of Latin square. It has nine rows and columns, to be filled in with the digits from 1 to 9. Coming up are two *color* sudokus for you to "solve" over breakfast: a 15 x 15 grid, and three 9 x 9 grids superimposed!

Latin squares are not symmetrical, but they are nevertheless perfectly balanced and harmonious. They make for nice quilts.

2	1	3	7	13	11	12	6	5	10	14	9	8	15	4
5	4	6	10	1	14	15	9	8	13	2	12	11	3	7
1	3	2	9	15	10	11	5	4	12	13	8	7	14	6
11	10	12	1	7	5	6	15	14	4	8	3	2	9	13
6	5	4	11	2	15	13	7	9	14	3	10	12	1	8
9	8	7	14	5	3	1	10	12	2	6	13	15	4	11
10	12	11	3	9	4	5	14	13	6	7	2	1	8	15
3	2	1	8	14	12	10	4	6	11	15	7	9	13	5
13	15	14	6	12	7	8	2	1	9	10	5	4	11	3
12	11	10	2	8	6	4	13	15	5	9	1	3	7	14
14	13	15	4	10	8	9	3	2	7	11	6	5	12	1
4	6	5	12	3	13	14	8	7	15	1	11	10	2	9
7	9	8	15	6	1	2	11	10	3	4	14	13	5	12
15	14	13	5	11	9	7	1	3	8	12	4	6	10	2
8	7	9	13	4	2	3	12	11	1	5	15	14	6	10

MEGADOKU

Choose a different color for each number from 1 to 15, then fill in the grid opposite following the numbers above.

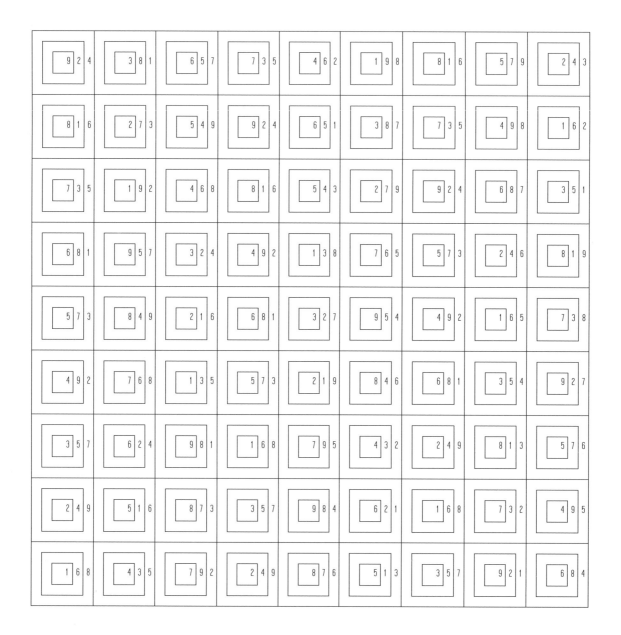

TRIDOKU

Choose a different color for each number from 1 to 9, and then fill in the grid opposite following the numbers above.

CELLULAR AUTOMATON

A row of squares ("cells") that evolves according to a set of rules

GENERATION GAME

First, randomly color about half the cells in the top row. Then, use this key to color the cells in the next row:

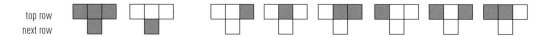

top row
next row

In other words, a cell should be colored if the three cells above it are *all* colored or *all* blank. It should be left blank if the three cells above it are mixed.

So if the top row looks like this:

Then the next row will look like this:

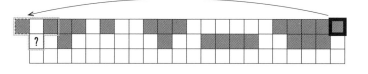

For the *first* cell in the new row, imagine moving the *last* cell in the top row to complete the key:

Similarly, imagine moving the *first* cell in the top row to complete the key for the *last* cell in the new row:

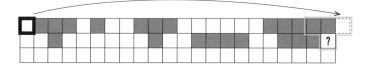

Color the following rows the same way, and watch your pattern grow. (Don't panic if you reach a row that's nearly all blank or all filled—keep going and see what happens!)

CONIC SECTIONS

The curves you get when you slice a cone

Here, you'll draw two such curves, the *parabola* and the *hyperbola*, using only straight lines.

PARABOLAS

Joining equally spaced points along two intersecting straight lines produces a parabola. Moving clockwise around this wheel, use a straightedge to connect the numbers that match. Each spoke will be connected *only* to the two nearest spokes.

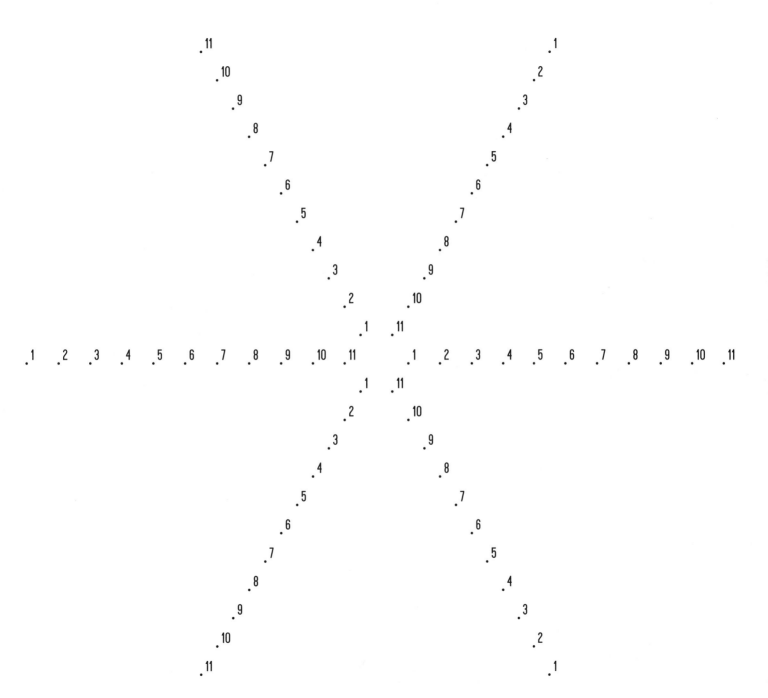

1 2 3 4 5 6 7 8 9 10 11 12 13 14 15 16

11 | 9, 13 8, 14 7, 15 6, 16 5, 15 4, 14 3, 13 2, 12 1, 11 2, 10 3, 9 4, 8 5, 7 6
10, 12

HYPERBOLOID

If you rotate a hyperbola around an axis you get the *hyperboloid*, a 3-D solid. Using a straightedge, follow the numbers to connect the bottom row of dots with the top row. Each of the dots on the bottom goes with *two* dots on the top, except for the very first and last.

PRIME NUMBERS

The prime numbers—2, 3, 5, 7, 11, 13, and so on—are the numbers that can only be divided by themselves and by 1

In 1963, the Polish-American mathematician Stanislaw Ulam put the natural numbers (1, 2, 3 . . .) into a grid in a spiral pattern, and then highlighted the prime numbers. The pattern that emerged is fascinating because it reveals a hidden order to the prime numbers: They seem to sit on the same lines. Try it yourself on the next page. No other single image captures the mysteries of mathematics so well.

16	15	14	**13**
5	4	**3**	12
6	1	**2**	**11**
7	8	9	10

400	399	398	**397**	396	395	394	393	392	391	390	**389**	388	387	386	385	384	**383**	382	381
325	324	323	322	321	320	319	318	**317**	316	315	314	**313**	312	**311**	310	309	308	**307**	380
326	**257**	256	255	254	253	252	**251**	250	249	248	247	246	245	244	243	242	**241**	306	379
327	258	**197**	196	195	194	**193**	192	**191**	190	189	188	187	186	185	184	183	240	305	378
328	259	198	145	144	143	142	141	140	**139**	138	**137**	136	135	134	133	182	**239**	304	377
329	260	**199**	146	**101**	100	99	98	**97**	96	95	94	93	92	91	132	**181**	238	303	376
330	261	200	147	102	65	64	63	62	**61**	60	**59**	58	57	90	**131**	180	237	302	375
331	262	201	148	**103**	66	**37**	36	35	34	33	32	**31**	56	**89**	130	**179**	236	301	374
332	**263**	202	**149**	104	**67**	38	**17**	16	15	14	**13**	30	55	88	129	178	235	300	**373**
333	264	203	150	105	68	39	18	**5**	4	**3**	12	**29**	54	87	128	177	234	299	372
334	265	204	**151**	106	69	40	**19**	6	1	**2**	**11**	28	**53**	86	**127**	176	**233**	298	371
335	266	205	152	**107**	70	**41**	20	**7**	8	9	10	27	52	85	126	175	232	297	370
336	267	206	153	108	**71**	42	21	22	**23**	24	25	26	51	84	125	174	231	296	369
337	268	207	154	**109**	72	**43**	44	45	46	**47**	48	49	50	**83**	124	**173**	230	295	368
338	**269**	208	155	110	**73**	74	75	76	77	78	**79**	80	81	82	123	172	**229**	294	**367**
339	270	209	156	111	112	**113**	114	115	116	117	118	119	120	121	122	171	228	**293**	366
340	**271**	210	**157**	158	159	160	161	162	**163**	164	165	166	**167**	168	169	170	**227**	292	365
341	272	**211**	212	213	214	215	216	217	218	219	220	221	222	**223**	224	225	226	291	364
342	273	274	275	276	**277**	278	279	280	**281**	282	**283**	284	285	286	287	288	289	290	363
343	344	345	346	**347**	348	**349**	350	351	352	**353**	354	355	356	357	358	**359**	360	361	362

ULAM SPIRAL

Use the key above to fill in the grid opposite. Color *just* the prime numbers (in bold), or pick a special color for them that will stand out.

SPACE-FILLING CURVES

Curves that will eventually fill a region of the plane

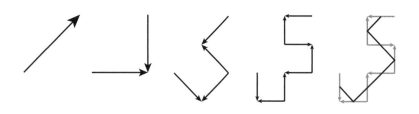

DRAGON CURVE

Join the dots.

Start with a line and replace it with two smaller lines at right angles. Replace those with even smaller lines. If you do this several times, and then join the midpoints (as shown by the darker lines in the final step above), you will produce the image in this book. The dragon curve was popularized by Michael Crichton, who used it on the section-title pages of Jurassic Park.

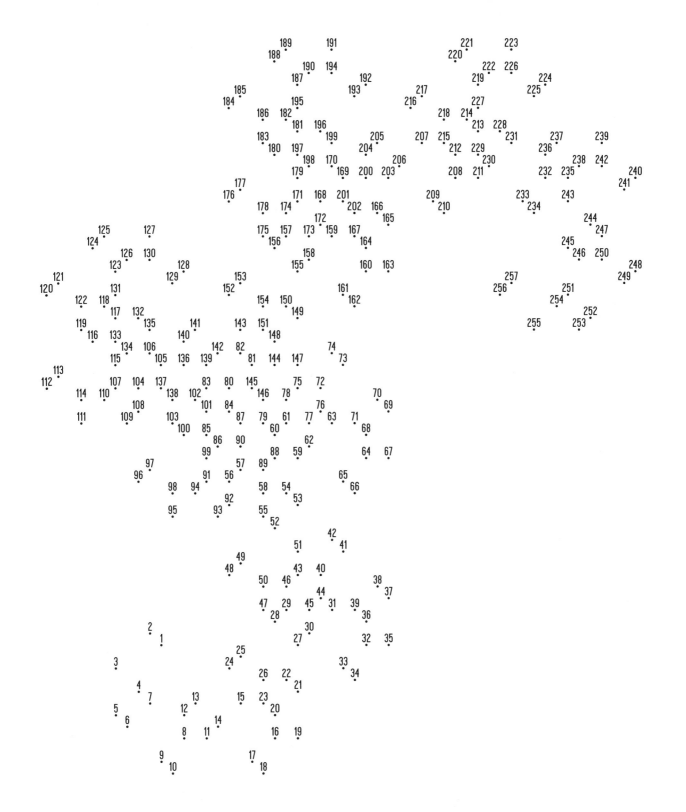

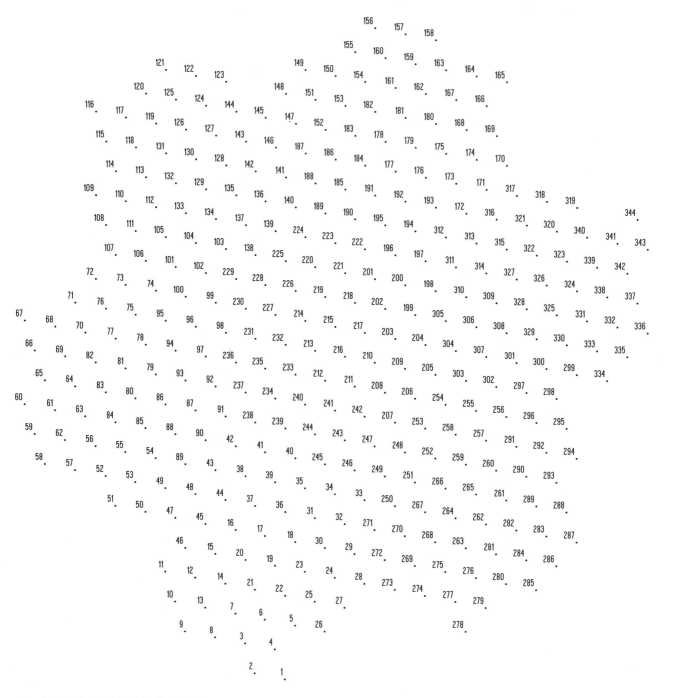

FLOWSNAKE

Join the dots. (See the Triple Flowsnake in the Coloring section for more about this curve.)